tomatoes

50 TRIED & TRUE RECIPES

Julia Rutland

Adventure Publications
Cambridge, Minnesota

Cover and book design by Jonathan Norberg
Edited by Emily Beaumont

Cover images: All images by Julia Rutland

All images copyrighted.

All images by Julia Rutland unless otherwise noted.

Used under license from Shutterstock.com:
Creatus: 9; **Elena Elisseeva:** 16 (heirloom tomatoes); **eugene-gurkov:** 2-3; **fotozick:** 15 (grape and pear tomatoes); **Bozena Fulawka:** 15 (cherry tomatoes); **GSDesign:** 15 (vine tomatoes); **MaraZe:** 6, 21; **OFC Pictures:** 15 (beefsteak tomato); **M. Unal Ozmen:** 15 (plum tomatoes); **J.D. Rogers:** 16 (green tomato)

10 9 8 7 6 5 4 3 2 1
Tomatoes: 50 Tried & True Recipes
Copyright © 2021 by Julia Rutland
Published by Adventure Publications
An imprint of AdventureKEEN
310 Garfield Street South
Cambridge, Minnesota 55008
(800) 678-7006
www.adventurepublications.net
All rights reserved
Printed in China
ISBN 978-1-59193-950-4 (pbk.); ISBN 978-1-59193-951-1 (ebook)

Acknowledgments

What a complete joy it is to work on a cookbook featuring one of my favorite foods! Many thanks to the creative people at AdventureKEEN for their encouragement and skill while shepherding this book from ideas to printed pages. Cheers to Brett Ortler, Emily Beaumont, Lora Westberg, and Liliane Opsomer!

As always, I want to thank my friends who are willing to taste my experiments, as well as my dear family: Dit, Emily Bishop, and Corinne, who also provide a bit of garden assistance. I'd like to give a special nod to my fellow members of the Loudoun County Master Gardeners, who never fail to give me a bit of horticultural advice with each visit to the Demo Garden (especially the part about not composting tomatoes unless you want countless volunteers in your flower beds the next year!) With that in mind, thanks to my chickens and roosters, who have greedily devoured the overripe or bird-pecked gems from my garden—tomatoes for eggs is a great trade.

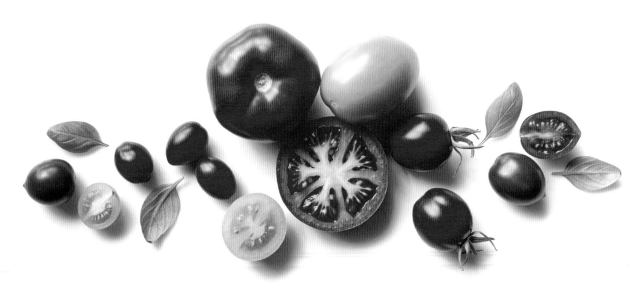

tomatoes

50 TRIED & TRUE RECIPES

Table of Contents

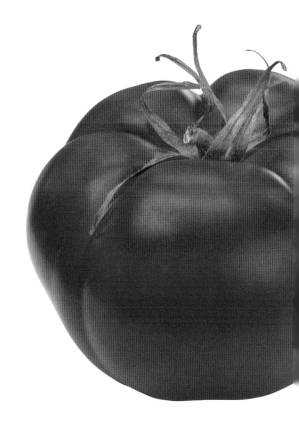

About Tomatoes

Of all the homegrown crops in the U.S., tomatoes rank as the most popular, with 86% of backyard gardeners planting them in their plots or pots. And it's not only fresh tomatoes we grow and eat. On average, Americans consume 23 pounds or more of processed tomatoes (think ketchup and sauce) every year.

Tomatoes are native to the Andes in Peru, but they didn't look like the large heavy globes we recognize now. The early wild tomato plants bore tiny fruit about the size of marbles. There is conflicting research about when tomatoes were domesticated, but it's clear that Indigenous peoples were growing them long ago. The conquistadors later brought them to Europe sometime in the sixteenth or seventeenth centuries. Through domestication and cultivation, tomatoes grew in size and in a variety of shapes and colors.

However, tomatoes were not always universally accepted by Europeans as safe to eat. Their inclusion in the nightshade family, alongside many poisonous plants (but also potatoes, eggplant, and tobacco), and their assumed corresponding toxicity made some Europeans briefly skeptical of tomatoes. But this skepticism gave way to delight, as tomatoes became a popular food throughout Europe. Tomatoes were introduced widely to the United States by Jewish merchants.

Jump ahead more than 200 years and tomatoes are the second most consumed vegetable behind potatoes. Botanically, tomatoes are a fruit, because they develop from a flower and contain seeds, but legally speaking, they are considered a vegetable. The story is a bit surreal: In the late nineteenth century, Congress passed The Tariff Act of 1883, which affected vegetables but omitted fruit. Tomato importers did not want to pay the 10% tax, so they argued that tomatoes were a fruit. A legal case wound its way to the United States Supreme Court for a decision. The justices unanimously decided that, in common language, tomatoes are considered a vegetable. They reasoned that fruit is usually served as dessert, and most people consider and use tomatoes as a savory item, often served with dinner.

Planting and Growing Tomatoes

Growing tomatoes is pretty easy, inexpensive, and doesn't require a traditional garden. There is a standard recommendation to have one to four plants per person, but the number of plants needed will vary depending on how much you and your family enjoy eating them and if you like to preserve the fruit for later consumption. A standard tomato plant will average 10 to 15 pounds of fruit. Tomato plants are self-pollinating (the flowers have both male and female parts), so there is no need for a second plant.

Technically a perennial, tomatoes are usually grown as annual plants because they will not grow indefinitely in most areas of the country. You can see the potential of a single tomato plant at Walt Disney World's Epcot Center. During the "Living with the Land" boat ride attraction, you can visit the world's largest tomato plant. The average harvest is around 14,000 golf ball-size tomatoes, but one year the plant produced a record-breaking 32,000-plus!

Site Selection

- Choose a garden space that receives at least 8 hours of sunlight. In cool Northern climates with short summers, the amount of sunlight is critical for healthy plants. If your summers are excessively hot, a bit of shade for a few hours will protect plants from wilting.

- Soil is a critical factor to ensure robust garden crops. Tomatoes are not exceedingly sensitive, but they will do poorly in heavy clay soils. Amend with compost, and consider contacting your local extension office for affordable soil testing.

- Rotate tomato patches, ideally every year. Pathogens in the soil can build up and cause diseases in subsequent years.

When to Plant Seeds

- For maximum harvests, start tomatoes indoors six to eight weeks before the last frost date in your area. Ensure adequate sunlight or artificial light to prevent spindly plants.

- Seven to ten days before transplanting, "harden off" the seedlings by placing them outdoors in the shade for a couple of hours each day, increasing the amount of time outside and slowly including some direct sun. This step helps acclimate the tiny plants to the change in sun, wind, and outdoor temperature.

- Make sure all danger of frost has passed and the soil has sufficiently warmed before planting in your garden. If planted too early in chilly temps, the plants won't reach their full potential.

- Tomatoes can develop roots along the stem. Deeply transplanting allows roots to develop and is also a good remedy for tall, leggy plants. Bury up to two-thirds of the plant in soil. If the stem is flexible, plant the root ball sideways so more of the stem is underground, and then curve it up to the top of the soil.

Planting Seedlings

- If purchasing started plants, avoid those with yellowing leaves, a sign of disease or distress. Choose plants with straight stems about the thickness of a pencil.

- Transplants perform better when planted in warm air and soil temperatures. While the air temperature warms first, the soil can still be cooler than ideal. Cover the soil with black plastic a few weeks before adding the tomatoes; this warms the soil and can be removed before planting, if desired.

- For both seeds and seedlings, select a variety suited for your climate. If you live in an area with a lot of warm days, you have more options and can select a variety with longer maturation times.

Cages and Other Support

- Make a plan to contain and control otherwise runaway tomato vines by using purchased cages, long stakes, or other gadgets designed for tomato plants. Unsupported tomato vines will sprawl along the ground, inviting a host of critters. Besides being easier to harvest, supported plants are more productive and suffer less from insect and disease issues. Contact with damp soil may also contribute to rot.

- If your garden is large and/or you have many plants, consider buying a roll of concrete wire or fence wire with large squares; you can use this to make cylinders for each plant.

- Place any stakes or cages around the plants at the time of transplanting. Doing it later in the season risks cutting roots and breaking vines.

Fertilizers and Mulch

- Fertilize with a product designed for tomatoes, as nitrogen-heavy blends will result in a lot of foliage growth and reduced fruiting.

- Mulch with organic material to keep the soil temperature and moisture levels consistent. Mulch also helps keep soil (and accompanying diseases) from splashing onto the plants during rain events, and it keeps any low-hanging fruit off of the ground.

Harvest

- For best flavor, allow your tomatoes to ripen to their mature color while on the vine. If your garden is at risk for bird or other animal damage, it's okay to pick when pink and allow them to ripen inside at room temperature.

- If your tomatoes are ripening and heavy rains are in the forecast, consider picking a little early. Tomatoes split or crack when the inside expands too fast for the skin to grow. This is common when a heavy rainfall follows a drought. Extreme fluctuations with irrigation can also cause this to occur. Pick such tomatoes immediately because what starts off as an aesthetic problem can get worse, as the skin protects the fruit from disease and insects.

Purchasing Tomato Plants

Heirloom vs. Hybrid vs. Grafting

Heirloom refers to traditional plant varieties that were developed before modern commercial agriculture and that have held steady characteristics for 50 years and often much more. Typically heirloom tomatoes are prized for their taste, as opposed to modern tomato hybrids that many feel sacrifice flavor in exchange for better growth, disease-resistance, and storage. These seeds have been passed down from generation to generation. Gardeners will find varieties with a wide range of characteristics, and farmers markets are ideal places to buy fully grown fruit. At their peak and for a short time, grocery stores may offer a few popular heirlooms varieties, including Brandywine and the dark reddish brown Cherokee Purple, both renowned for their rich, sweet flavor and dense texture.

Hybrid plants are the result of cross-pollinating two different tomato varieties; this creates a new plant that exhibits certain traits. The benefits of a hybrid plant include: vigor, higher yields, uniformity among fruit (which is more important to commercial processors than home cooks), and increased disease and insect resistance (which can mean less chemical intervention). Hybrid plants typically only exhibit their improved qualities in the first generation after crossbreeding, so hybrid seeds need to be purchased anew each season. Tomato breeders are constantly experimenting with crosses (pollinating one variety with another) to increase positive traits. Currently there are no GMO (genetically modified) tomatoes commercially available.

Grafting is the use of special techniques to join two or more plants together in order to take advantage of the characteristics of both. Instead of crossing the genes between the varieties, one variety becomes the rootstock, and the other becomes the scion, the top or fruit-bearing part of the plant. Common examples include fruit trees and grapevines. Grafting plants enables growers to combine a rootstock that is resistant to soil-based diseases with a top plant that is prolific with a particular fruit. If purchasing grafted plants, it is critical to keep the union (usually a thicker, lumpy area around the stem) above the soil. If buried, the top will form roots and grow, invalidating the graft.

Tomato Plant Terminology

There are several different terms to be aware of when purchasing tomato plants. Here's a rundown:

- Midget, patio, or dwarf varieties grow on compact vines and are ideal for container planting. In general, these are short-lived compared to sprawling garden-growing plants, and much of the crop will ripen in a short period.

- Determinate plants grow to a particular size before flowering, setting fruit, then declining. Most commercial plants are determinate since their growth cycle can be timed for optimal harvest.

- Indeterminate plants have vines that continue to grow until frost or disease kills them. They will require support for the best yields. Without wire cages or trellises, indeterminate tomato plants will sprawl along the ground, making them more tempting to critters.

Contact your local extension office and/or Master Gardener Association for tips and pointers specific to your location.

Purchasing Ripe Tomatoes

There are several different kinds of fresh tomatoes, each with specific uses. Here is a quick primer on the main categories.

Cherry: These small, round tomatoes range in size from that of a small blueberry to as large as a golf ball. They are often sweeter than their larger counterparts and are great in green salads and pasta salads, stuffed as small appetizers, or simply eaten whole. Growing cherry tomatoes in your garden is initially satisfying because they are some of the first to mature. But take care not to overplant because a healthy plant can produce copious amounts.

Grape and pear: Grape and pear tomatoes are some of the smallest you'll find in markets, generally sold prepacked in all red, yellow, or multi-colored mixes. Grape tomatoes are oblong and about the same size as a grape; pear tomatoes have a small neck (at the stem end) and a rounded end. They are crisp and juicy with a well-balanced sweet-acidic flavor.

Plum: Easily recognized by their long, cylindrical shape, plum tomatoes are also called "paste" tomatoes and sometimes sold as "Romas," a variety of plum tomatoes. These are often used in sauces because they are meaty with few seeds and have a low water content.

"Tomatoes on the vine": Sold in clusters connected by the vine they grew on, these tomatoes are very consistent in their size and ripeness. They are usually larger than cherry tomatoes and smaller than beefsteaks. The hybrid tomatoes are cultivated for their sweetness, lack of mealiness, low acidity, and deep red color.

Beefsteak: These large, meaty tomatoes are often eaten fresh since their irregular shapes make them difficult to commercially process. However, their squatty profile makes them great for sandwiches, as their wide shape means you can add one large slice rather than stacking a few smaller slices. Beef-steak varieties have some of the longest lengths of maturation, so don't delay planting if you live in a climate with a short season. Supporting the vines is important because fruits are large, weighing around 1 to 2 pounds each.

Heirlooms: There are many different heirloom tomatoes; popular examples include Brandywine and the dark reddish brown Cherokee Purple, both renowned for their rich, sweet flavor and dense texture. Heirloom tomatoes generally have less disease resistance and a shorter shelf life than homegrown or commercial hybrid tomatoes.

Green: The majority of green tomatoes are simply mature, but unripe, tomatoes. The exception are certain varieties, such as Green Zebras, that remain green when fully ripe. When temperatures drop, tomatoes on the vine stop ripening, which is why you'll see more green tomatoes at the market in fall. Very immature green tomatoes never ripen, but you can try to ripen fruit that has reached its full size. To do so, place it in a bag with an apple or bananas; these fruits emit ethylene gas, which catalyzes ripening.

The firm and dense texture of green tomatoes makes them ideal for breading and frying. I stay away from the rock-hard green tomatoes, as I find their texture a bit too "squeaky." I look for green tomatoes with a slight bit of "give" in the sides or those that have become "breakers."

Vine-ripe vs Ripe Tomatoes

The term "vine-ripe" means different things. The term implies that the tomato grew and ripened to red (or whatever the mature color) while still attached to the vine. And that's how many home gardeners and local farmers markets handle their crops. However, store-bought tomatoes are usually picked green—specifically "mature green," meaning the fruit has developed to its full size and will eventually turn red. Commercial growers do this since mature green tomatoes are firm enough to handle packing and transportation without bruising. In addition, store-bought tomatoes are specifically bred to have sturdy skins that can handle the weight of being packed together into large boxes. The green tomatoes are packed into containers and treated with ethylene gas to promote ripening.

Another benefit of picking mature green tomatoes and treating is that the entire batch or box will ripen evenly and at the same time. Ethylene gas is a natural plant hormone that controls the plant's development and occurs in many other foods, such as apples and bananas.

Note that processed tomatoes (paste or plum tomatoes) are allowed to ripen on the vine in the field. They are processed very soon after harvesting; therefore, these products are often more flavorful.

Stages of ripening:

1. Green: The entire surface and interior of the tomato is pale or bright green.

2. Breakers: There is a distinct show of color from a light pink on not more than 10% of the surface.

3. Turning: More than 10% of the tomato shows a change from green to a yellowish color, but no more than 30%.

4. Pink: More than 30% of the tomato shows a yellowish pink to red color, but not more than 60%.

5. Light red: More than 60% of the surface is a pinkish-orange color.

6. Red: More than 90% of the tomato is a vivid and deep red.

Processed or Canned?

While the image of a tomato is usually a round, baseball-size fresh globe, most of the tomatoes eaten in the U.S. are not fresh but occur in the form of ketchup and tomato sauce. For fresh recipes like salads, you want the best fresh tomato. But for sauces, casseroles, and soup, canned tomatoes make an excellent option.

"Processed" is an accurate yet unappetizing term for canned or tinned tomatoes. While the ultimate tomato is a big, juicy one that has been fully ripened on the vine, you won't have access to one unless you are growing them yourself in big quantities. Commercially processed tomatoes, generally plum/Roma tomatoes, are harvested at peak flavor, when they are ripe and red. They're processed a few hours after picking.

Canned tomatoes have rich flavor; there are also many options in terms of seasonings, from tomatoes with Italian spices to chili or Mexican-style tomatoes or fire-roasted ones.

Remember that tomatoes are very acidic and can leach BPA, a chemical linked to potential health problems, from the lining of the cans. Look for brands labeled without BPA or buy tomato products in coated paper cartons or glass jars.

Types of Processed or Canned Tomatoes

Whole, peeled tomatoes are packed in tomato juice or puree. This very basic form can be chopped, crushed, pureed, or used in sauces.

Stewed tomatoes used to be popular as a side dish. The canned types have been cut and cooked, often with seasonings and some sugar. Their texture is soft, and they are used in recipes that call for larger pieces.

Diced tomatoes have been chopped into fairly consistently sized cubes; calcium chloride is added to help them retain their shape. This type is good for soup, chili, and sauces where you want to see pieces of tomato intact.

Crushed canned tomatoes are softer than diced, but they retain more texture than pureed tomatoes or tomato sauce.

Puree is sometimes called ground tomatoes. It is a thick sauce with a texture in between that of crushed and paste.

Sauce consists of pureed tomatoes, often with added seasonings with a very smooth texture. Note: Ready-to-serve pasta sauces are usually in larger containers. They are highly seasoned, with texture running from smooth to chunky.

Paste, in small cans or tubes, contains tomatoes that have been cooked down to a very thick consistency. The flavor is quite concentrated, and the color is dark. Recipes often use a few tablespoons out of a can, which can be wasteful if the remainder is not used right away. You can freeze cubes or tablespoons of tomato paste.

San Marzano plum tomatoes originated in the Italian town of San Marzano sul Sarno, not far from Naples; these are sold canned and are renowned for their rich flavor and mild acidity. Some of these tomatoes were given a special status—when you see "D.O.P" on a San Marzano label, it signifies that they are an Italian product certified to be locally grown and packaged. D.O.P. stands for an Italian term that translates to "Protected Designation of Origin." It's very similar to the similarity/differences between Champagne and sparkling wine. It is the same tomato, only grown outside the particular Italian region.

Sun-Dried Tomatoes have a tart and slightly sweet flavor, with a texture like other dried fruit. For as long as people have been eating tomatoes, they have been finding ways to preserve their excess harvest and keep them edible for future use. Traditionally, tomatoes (usually plum) were halved, salted, and dried on rooftops in the sun, and then submerged in olive oil. The slow drying process in the sun is said to enhance their flavor.

It's doubtful that any sun-dried tomatoes you purchase nowadays were actually dried in the sun. Tomatoes destined for drying are often treated with sulfur dioxide to preserve their bright red color and then dried in commercial dehydrators.

Very fresh sun-dried tomatoes can be used without rehydrating, as they are pliable. Older ones turn very dark and may require some soaking in hot water to become edible. Some sun-dried tomatoes are packed in oil, with or without additional seasoning. These are soft and ready to use, and you can save the oil for sautéing or for use in salad dressings.

Nutrition, Storage, and Peeling

Nutrition

A medium-size tomato has about 35 calories and is rich in vitamins C, A, and K. Red tomatoes contain more beneficial nutrients than yellow or green tomatoes. But tomatoes are especially famous for their high levels of lycopene and beta-carotene. Lycopene is the nutrient responsible for the red pigments in tomatoes, bell peppers, watermelons, and grapefruit. It is associated with a reduced risk of heart disease and cancer.

Tomatoes and tomato products contain more lycopene than most other fruits and vegetables, and sun-dried tomatoes contain nearly twice as much.

Cooking tomatoes increases the bioavailability of lycopene, especially if you're heating tomatoes along with a fat, such as extra-virgin olive oil, since lycopene is a fat-soluble nutrient.

Storage

Don't store tomatoes in the refrigerator. The cool temperatures halt enzymes that produce aroma and that yummy umami flavor. You may have heard to store tomatoes at room temperature, but there's a caveat. Food scientists recommend 55°F as best (same as red wine!). Refrigerators, on average, keep foods at 34°F to 38°F, but your kitchen, especially in the summer, usually surpasses 70°F and may even reach temps in the 90°F range. You may need to be flexible. Unripe to ripe tomatoes can stay out on the counter, but if you can't use them before they rot, place in the refrigerator to halt the ripening process to avoid oversoft and leaking fruits. If stored in the refrigerator, let them rise back to room temperature before eating to help recover some of the lost flavor and aroma. Previously chilled tomatoes are best in sauces and soups.

Store tomatoes stem up to avoid bruising the tender "shoulders." If you crowd them together in a bowl or basket, check them frequently, as the ones on the bottom may ripen much faster and split from the weight of the fruit above.

Peeling

Some cooks prefer to peel tomatoes before using them in soups and sauces. Removing the skins when making sauces helps to create a very smooth, silky texture. It also helps you avoid having bits of tomato skin floating around (if that even bothers you). Using a food processor or immersion blender can grind the skin pieces to such a fine size that they are not really noticeable.

Like many other fruits and veggies, the skins hold a lot of nutrition (in tomatoes, that's where most of the lycopene exists), and removing them reduces the health benefits. Since I don't mind the bits of skin, and I want the maximum amounts of antioxidants, I didn't peel the tomatoes for recipes in this book.

To peel tomatoes, make a small "x" on the bottom of the tomato. Gently lower into gently boiling water to cover the tomato (remember to take off any stickers!). Let it soak in the boiling water for 15 to 30 seconds (you will see the cut edges of the skin start to curl away). Then drain in a colander; when cool enough to handle, slip off the skins.

sauces
and
salsas

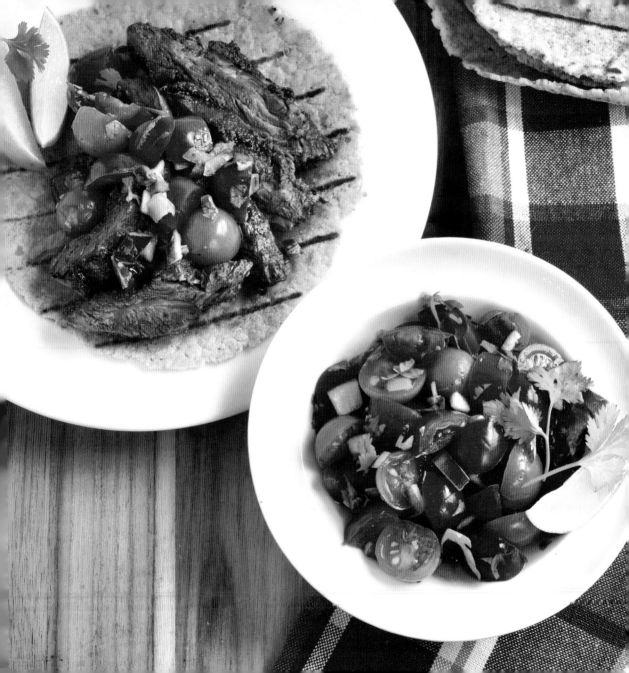

Pico de Gallo

Pico de gallo and salsa share many of the same ingredients, but it's the texture that is notably different. Pico is chunky and uses fresh, uncooked tomatoes. Salsa usually has a finer, thinner consistency. Pico makes a great topping for grilled meats and vegetables, but its larger size can be awkward to use as a dip with chips. If you want to make this dippable, finely chop the ingredients or toss them in a food processor for a few seconds. I use cherry tomatoes in this chunky fresh dip because, when they start to ripen in my garden, I tend to have hundreds to deal with, but you may substitute 2 to 3 traditional tomatoes, seeded and chopped.

makes 2 cups

INGREDIENTS
2 cups cherry or grape tomatoes, quartered or chopped
¼ small red onion, finely chopped
1 garlic clove, minced
½ cup chopped fresh cilantro
½ teaspoon grated lime zest
3 to 4 tablespoons fresh lime juice
¾ teaspoon salt

Combine all ingredients in a bowl. Cover and chill until ready to serve.

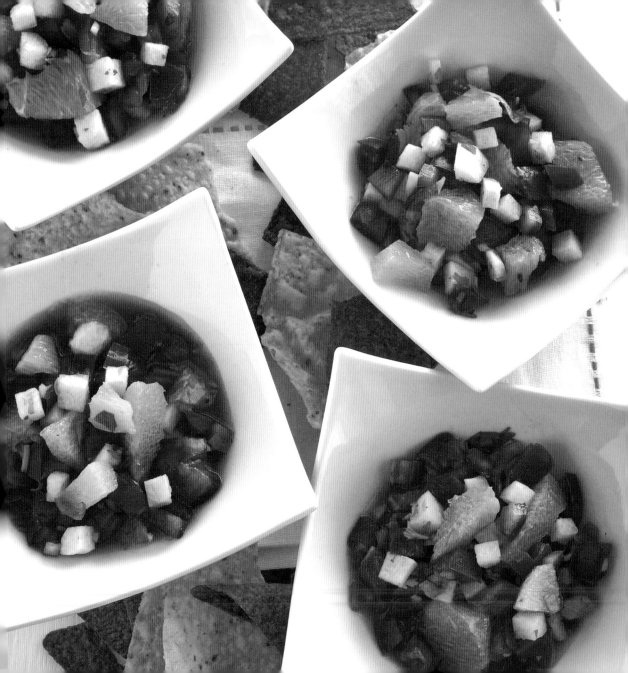

Smoky Jicama–Orange Salsa

Oranges add a bit of sweetness that pairs well with ripe acidic tomatoes. Jicama adds
a neutral flavor but lots of crunch (as well as a good portion of the gut-friendly prebiotic fiber inulin).
You can substitute extra bell pepper or some celery for a similar texture, or skip it altogether.

makes 4½ cups

INGREDIENTS

4 medium-size (1½ pounds)
 tomatoes, seeded and chopped
1 cup finely chopped jicama
½ red bell pepper,
 finely chopped
¼ small red onion,
 finely chopped
3 tablespoons fresh lime juice
1 teaspoon ground cumin
2 teaspoons chopped
 canned chipotle peppers
 in adobo sauce
1 teaspoon orange zest
2 navel oranges, peeled and cut
 into segments
¼ cup chopped fresh cilantro
1 teaspoon salt

Combine tomatoes, jicama, bell pepper, onion, lime juice,
cumin, and chipotle peppers in a large bowl, stirring until
well blended. Stir in zest, orange segments, cilantro, and salt.
Cover and chill until ready to serve.

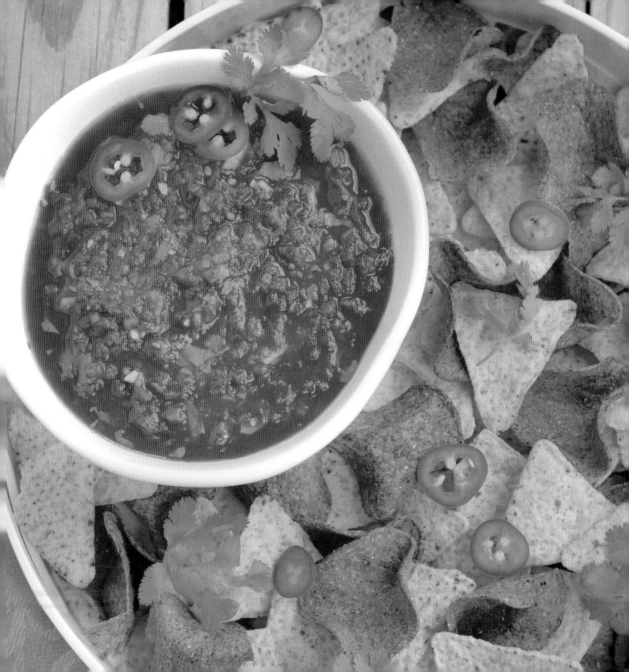

Restaurant-style Salsa

I call this salsa "restaurant-style" because I blend the ingredients into a somewhat smooth texture, similar to the bowls of sauce placed on tables with crisp tortilla chips. The canned tomatoes are a great shortcut and ideal when fresh tomatoes are out of season and bland. It still has a bright, fresh flavor with the addition of cilantro and lime zest. If your garden is overflowing, try this with 6 medium-size tomatoes, seeded and chopped, and a minced jalapeño.

makes 5 cups

INGREDIENTS

2 (14.5-ounce) cans fire-
 roasted whole or diced
 tomatoes, undrained
1 (10-ounce) can diced
 tomatoes with green
 chilies, undrained
¼ medium-size yellow or
 white onion
2 garlic cloves, coarsely chopped
½ cup fresh cilantro leaves
1 teaspoon lime zest
3 tablespoons fresh lime juice
1 teaspoon salt

Combine tomatoes, onion, garlic, and cilantro in a food processor; blend until very finely chopped. Add zest, juice, and salt; pulse until well blended.

Transfer to a bowl. Cover and refrigerate until well chilled. Stir just before serving.

Tomato–Olive Relish

This unique mixture makes an interesting dip when served with pita chips.
Try it as a flavorful topping to jazz up grilled chicken or plain fish.
It's full-flavored, so the relish works well with bold seafood such as grilled sockeye salmon.

makes 3½ cups

INGREDIENTS

1 (15-ounce) can pitted ripe
 black olives, drained
1 cup pimento-stuffed
 green olives
¼ cup chopped yellow onion
2 tablespoons drained capers
3 small garlic cloves, chopped
¼ teaspoon crushed red
 pepper flakes
2 teaspoons chopped fresh
 oregano or basil
1 tablespoon red wine vinegar
3 large tomatoes, seeded and
 coarsely chopped

Combine black and green olives, onion, capers, garlic, red pepper flakes, oregano, and vinegar in a food processor; pulse until coarsely chopped. Add tomatoes; pulse until evenly blended.

Caponata

Caponata shares a lot of the same ingredients with ratatouille, except that it has more of a sweet-and-sour flavor, while ratatouille is all savory. The flavors marry well when refrigerated overnight, and you can serve it chilled or at room temperature. Use the relish as a topping for bruschetta or toasted baguette slices.

makes 4½ cups

INGREDIENTS

1 eggplant, peeled and cubed
1 teaspoon salt
¼ cup extra-virgin olive oil, divided
1 small onion, chopped
1 red, yellow, or orange bell pepper, chopped
3 small celery stalks, thinly sliced
2 garlic cloves, minced
¼ teaspoon crushed red pepper flakes
6 to 8 large (1½ pounds) plum tomatoes, seeded and chopped
2 tablespoons tomato paste
2 tablespoons sherry or red wine vinegar
¼ cup golden or dark raisins
¼ cup sliced kalamata olives
2 tablespoons capers, rinsed and drained
1 tablespoon honey
2 tablespoons chopped fresh parsley
2 tablespoons chopped fresh mint
Toasted pine nuts (optional)

Place eggplant in a large bowl and sprinkle with 1 teaspoon salt, tossing to coat. Set aside for 20 to 30 minutes. (Meanwhile, prep the rest of the ingredients. Salting the eggplant is optional but can remove excess bitterness.) Drain the brine from the bottom of the bowl. Pat eggplant dry with paper towels.

Heat 2 tablespoons olive oil in a large skillet over medium heat. Add eggplant. Cook, stirring frequently, for 5 minutes or until eggplant is golden brown and tender. Transfer to a bowl and set aside.

Heat remaining 2 tablespoons olive oil in the same large skillet. Add onion, bell pepper, celery, garlic, and red pepper flakes. Cook, stirring frequently, for 5 to 7 minutes or until tender. Add tomatoes and tomato paste. Cook, stirring frequently, for 5 minutes or until tomatoes are tender. Stir in vinegar, raisins, olives, capers, and honey. Cook, stirring occasionally, for 5 minutes or until liquid evaporates and mixture is thick. Stir in reserved eggplant, parsley, and mint.

Let cool to room temperature. Add additional salt, if necessary. Serve at room temperature or chilled. Sprinkle with pine nuts, if desired.

Spicy Vodka Sauce

Adding vodka (or another alcohol) helps release flavors in a simple cooked tomato sauce. It also helps to emulsify the fats and liquids, improving the texture. If you prefer to skip the vodka, you can substitute ⅓ cup water with 1 tablespoon fresh lemon juice. Serve with hot cooked pasta such as penne, gemelli, or another short noodle.

makes 3½ cups

INGREDIENTS

2 tablespoons extra-virgin olive oil
1 small sweet onion, chopped
½ teaspoon crushed red pepper flakes
3 garlic cloves, minced
½ cup vodka
1 (28-ounce) can whole peeled San Marzano tomatoes
¾ cup heavy whipping cream
1 tablespoon tomato paste (optional)
1 tablespoon balsamic vinegar
1 teaspoon sugar
½ teaspoon salt
Hot cooked pasta

GARNISHES

Fresh basil sprigs, freshly grated Parmesan cheese

Heat olive oil in a large skillet over medium-high heat. Add onion and red pepper flakes. Cook, stirring frequently, for 5 minutes or until tender.

Stir in garlic. Cook, stirring frequently, for 1 minute. Add vodka. Cook, stirring frequently, for 1 minute or until most of the liquid evaporates.

Stir in tomatoes, cream, tomato paste, vinegar, sugar, and salt. Bring mixture to a boil; reduce heat to medium-low, and simmer for 15 to 20 minutes, stirring and mashing tomatoes to blend. Serve with pasta. Garnish, if desired.

Quick Fresh Pizza Sauce

Pizza sauce contains all the same ingredients as a regular pasta
or marinara sauce, with a bit of extra oregano to give it that distinct flavor.
Pasta sauces are simmered on the cooktop while pizza sauces are used raw.

makes 3 cups

INGREDIENTS

2½ pounds very ripe plum or
 medium-size tomatoes
1 tablespoon tomato paste
1 tablespoon extra-virgin
 olive oil
1 tablespoon Italian seasoning
2 teaspoons dried oregano
1 teaspoon salt
1 teaspoon sugar
½ teaspoon garlic powder
⅛ teaspoon crushed red
 pepper flakes

Cut tomatoes in half and squeeze to remove all of the seeds and liquid. Coarsely chop and transfer to a food processor. Add tomato paste, oil, Italian seasoning, oregano, salt, sugar, garlic powder, and red pepper flakes. Pulse several times until finely chopped.

Variation: A great shortcut to this recipe is to substitute **1 (28-ounce) can crushed tomatoes** for fresh tomatoes. Do this when fresh tomatoes are out of season, unripe, or a bit mealy. Drain canned tomatoes, reserving liquid. Combine canned tomatoes with the remaining ingredients in a large bowl. Add tablespoons of the reserved liquid until the sauce reaches its desired consistency.

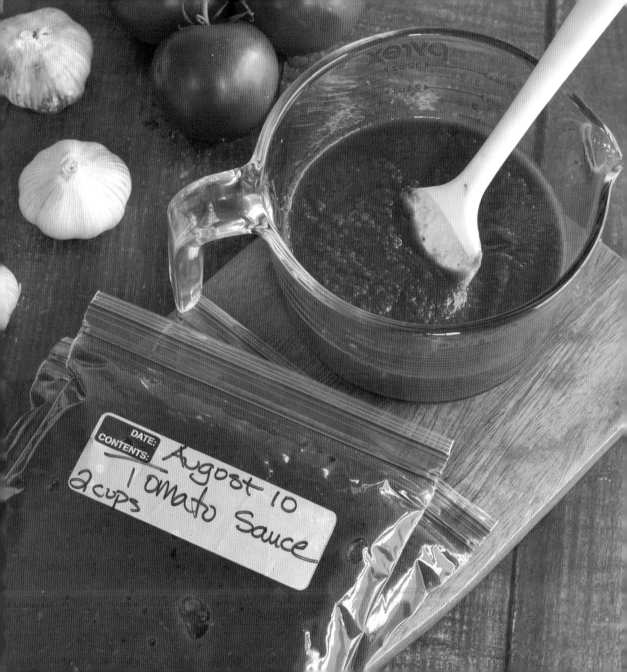

DATE: August 10
CONTENTS: Tomato Sauce
2 cups

Insta-fresh Tomato Sauce

If you own an Instant Pot or other multicooker, you already know how well they save time.
I now use the versatile gadget to make sauce instead of babysitting a pot of tomato sauce for hours,
needing to stir it occasionally so it doesn't scorch on the cooktop. The only downside (and an easy one to fix)
is that the sauce might be thin because no liquid evaporates during cooking. The consistency depends
on the type of tomato. If thin, remove the lid and use the sauté function for 10 to 15 minutes to reduce
the sauce. I've tried this with Romas, random garden tomatoes, and—one year—24 pounds of cherry tomatoes!
For cherry tomatoes, I just slice them in half and squeeze to remove seeds, if convenient. Then after pureeing,
I'll run the sauce through a sieve to remove the rest of the pesky seeds.

makes 6 cups

INGREDIENTS

- ¼ cup extra-virgin olive oil
- 2 large sweet onions, coarsely chopped
- 2 yellow, red, or orange bell peppers
- 6 garlic cloves, coarsely chopped
- 2 to 3 tablespoons dried Italian seasoning
- 2 teaspoons unsweetened cocoa powder
- ¼ to ½ teaspoon crushed red pepper flakes
- 1 tablespoon sea salt
- 1 (6-ounce) can tomato paste
- ½ cup red wine
- 6 pounds fresh tomatoes, quartered and seeded
- 1 to 2 teaspoons sugar (optional)

Pour olive oil into the multicooker and turn it on. Add onions and bell peppers; sauté for 5 minutes. Turn off heat and stir in garlic, seasoning, cocoa powder, red pepper flakes, salt, tomato paste, and wine. Stir in tomatoes.

Set the cooker to manual (high) and set the timer for 25 minutes. When cooking is complete, allow the pressure to release naturally. Blend with an immersion blender until you get the desired texture. If thin, use the sauté function (with lid removed) for 10 to 15 minutes or until reduced. If the sauce is overly acidic, stir in 1 to 2 teaspoons sugar.

Freezing and Storing: I prefer to freeze the sauce because canning requires additional lemon juice to ensure adequate acid for shelf-stable food safety. Let cool to room temperature and measure into zip-top plastic freezer bags (I pour 2 cups into a quart-size bag). Seal bags and lay flat on a baking sheet and freeze. Then you can remove the baking sheet and store in the freezer for 3 to 6 months.

Simple Cherry Tomato Pasta Sauce

It's remarkable how much flavor a sauce with few ingredients can have.
It's all about the tomatoes, and I find vine-ripened cherry, pear, and grape
tomatoes offer giant bursts of flavor in small morsels.
For a nice chunky texture, keep the smallest tomatoes whole.

makes 4 servings

INGREDIENTS
½ cup extra-virgin olive oil
5 garlic cloves, sliced
¼ teaspoon crushed red
 pepper flakes
6 cups or 2 (16-ounce) containers
 assorted cherry, pear, or grape
 tomatoes, halved
1 teaspoon salt
½ teaspoon coarsely ground
 black pepper
½ cup chopped fresh basil
Hot cooked pasta
Freshly grated Parmesan cheese
 or fresh mozzarella

Heat oil in a large skillet over medium-low heat. Add garlic and red pepper flakes; cook, stirring constantly, for 5 minutes. Do not allow garlic to over-brown.

Add tomatoes and salt. Cook, stirring constantly, for 5 minutes or until tomatoes are tender and mixture is saucy. Remove from heat; stir in pepper and basil.

Serve over pasta and sprinkle each serving with cheese.

Tomato–Short Rib Pasta Sauce

Beef short ribs are notable for their amazing flavor and texture.
All this is thanks to the well-marbled pieces of meat that are usually
braised for hours, resulting in fall-off-the-bone tenderness. It's normal
to see a fair amount of fat, but look for pieces with the most meat.

makes 8 cups

INGREDIENTS

2½ to 3 pounds beef short ribs
½ teaspoon salt
½ teaspoon coarsely ground
 black pepper
2 tablespoons olive oil
2 celery stalks, chopped
1 large carrot, peeled
 and chopped
2 garlic cloves, chopped
¼ teaspoon crushed red
 pepper flakes
10 to 12 ounces mixed wild or
 button mushrooms, quartered
2 (28-ounce) cans whole or
 crushed tomatoes, undrained
½ cup red wine
1 bay leaf
1 teaspoon sugar (optional)
Hot cooked pasta

GARNISHES

Shaved Parmesan cheese, Italian
 parsley sprigs

Preheat oven to 350°.

Sprinkle short ribs with salt and pepper. Heat oil in a Dutch oven or heavy deep skillet over medium-high heat. Add short ribs and cook for 2 minutes on each side or until browned. Transfer short ribs to a plate.

Drain excess oil from pan, leaving 1 tablespoon oil to coat the bottom; return to medium heat. Add celery, carrot, garlic, red pepper flakes, and mushrooms. Cook, stirring frequently, for 5 minutes. Combine tomatoes, wine, and bay leaf; stir into vegetable mixture. Add short ribs.

Cover and bake for 3 hours or until the meat is very tender and pulls easily off the bone. Remove and discard bay leaf. Remove short ribs; let meat stand until cool enough to handle.

While short ribs cool, skim off excess fat from the top of the remaining tomato sauce mixture. Remove bones and tough inedible pieces and discard. Shred meat into bite-size pieces and stir back into the tomato mixture. Taste and add more salt and pepper, if desired. For less bite, stir in 1 teaspoon sugar. Serve over pasta. Garnish, if desired.

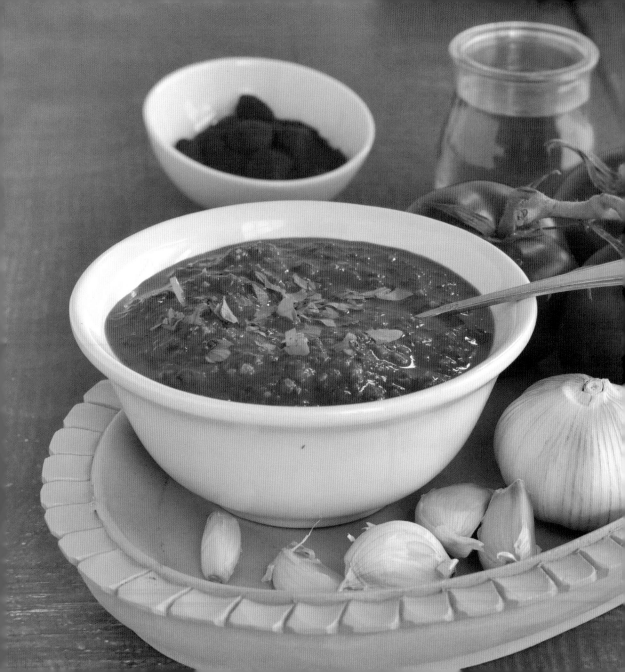

Roasted Tomato Romesco Sauce

Nuts add texture; however, for maximum flavor, toast them to a light golden brown before adding to the rest of the ingredients. Spread them out on a sheet pan and bake at 350° for about 5 minutes. You can also use a toaster oven, but watch carefully because the heating elements are closer to the nuts and they may burn quickly. Shake the pan periodically for even browning. If desired, substitute 1 (15-ounce) can diced tomatoes (undrained) and 2 jarred roasted bell peppers (well drained) instead of the fresh ingredients and skip the roasting procedure. Serve the sauce with grilled meats and veggies, or as a dip for a crudités platter.

makes 3 cups

INGREDIENTS
3 large (about 1¾ pounds)
 ripe tomatoes
2 red bell peppers, halved
1 large garlic clove,
 coarsely chopped
½ cup slivered almonds, toasted
2 tablespoons chopped
 fresh parsley
½ teaspoon salt
¾ teaspoon smoked paprika
2 tablespoons sherry vinegar
½ cup extra-virgin olive oil

GARNISH
Chopped fresh parsley

Preheat broiler. Line a sheet pan with aluminum foil.

Cut tomatoes and peppers in half. Remove cores and seeds. Place the vegetables, skin side up, on the baking sheet. Broil for 15 minutes, rotating pan occasionally, until skins are blackened. Let stand until cool enough to handle. Remove skins.

Combine tomatoes, bell peppers, garlic, almonds, parsley, salt, paprika, and vinegar in a food processor. Process until finely chopped. Add oil; process until smooth. Adjust the seasonings, if desired. Garnish, if desired.

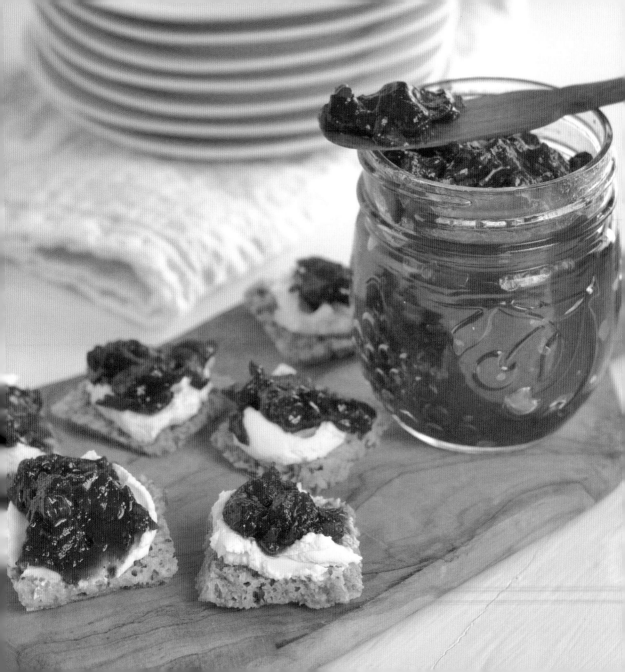

Tomato Jam

I'm never confident calling this yummy spread a jam when the spicy flavors are so reminiscent of chutney.
No matter the name, it tastes delicious with barbecued meats or as a simple topping for a log of goat cheese and crackers.
Whenever I make it, the time it takes to reduce it to a nice jammy consistency varies
(because different types of tomatoes have different moisture contents), so go by texture, not the timer.

makes 1½ cups

INGREDIENTS

2 pounds ripe tomatoes
½ cup firmly packed light
 brown sugar
½ cup firmly packed dark
 brown sugar
3 tablespoons apple cider vinegar
2 tablespoons fresh lemon juice
1 tablespoon minced fresh ginger
1 teaspoon salt
1 teaspoon ground cumin
½ teaspoon ground cinnamon
¼ teaspoon ground cloves
¼ teaspoon ground
 cayenne pepper

Core tomatoes and cut into wedges. Remove seeds and any gel or liquid. Coarsely chop tomatoes and transfer to a medium nonaluminum saucepan. Stir in brown sugars, vinegar, lemon juice, ginger, salt, cumin, cinnamon, cloves, and cayenne.

Bring mixture to a boil. Reduce heat to medium-low and simmer, stirring frequently, for 30 to 60 minutes or until the mixture thickens to a jam-like consistency. Watch carefully toward the end to avoid scorching.

Cool to room temperature. Transfer to jars or other airtight containers. Store in the refrigerator for up to 2 weeks.

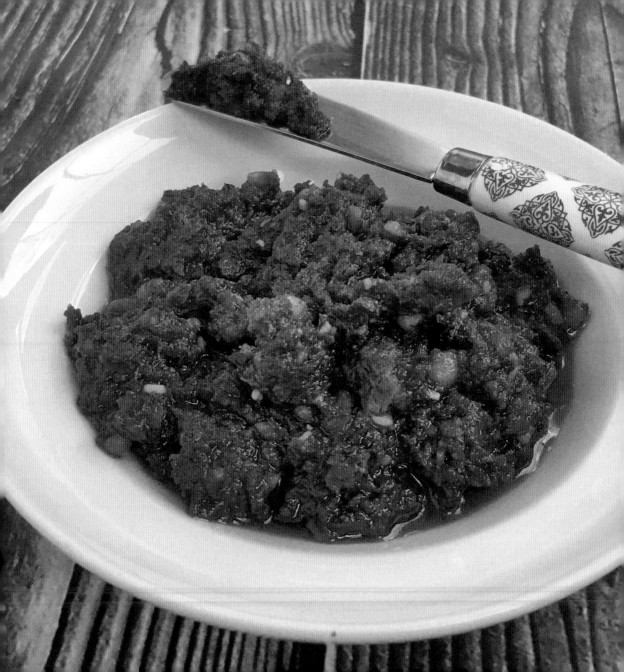

Sun-Dried Tomato Pesto

A little bit of this intense flavor goes a long way. Dollop on hot cooked pasta or spread over grilled fish or chicken. If you use plain tomatoes, add ½ teaspoon dried Italian seasoning to the mix.

makes 1⅓ cups

INGREDIENTS

1 (8.5-ounce) jar Italian seasoned sun-dried tomatoes in oil, drained
1 large garlic clove, coarsely chopped
¾ cup lightly packed fresh basil
½ cup extra-virgin olive oil
¼ cup (1 ounce) grated Parmesan cheese
2 teaspoons red wine vinegar
¼ teaspoon salt
Pinch crushed red pepper flakes
2 tablespoons toasted pine nuts

Combine tomatoes, garlic, basil, oil, Parmesan cheese, vinegar, salt, and red pepper flakes in a food processor. Process until very finely chopped.

Add pine nuts. Pulse several times or until evenly chopped.

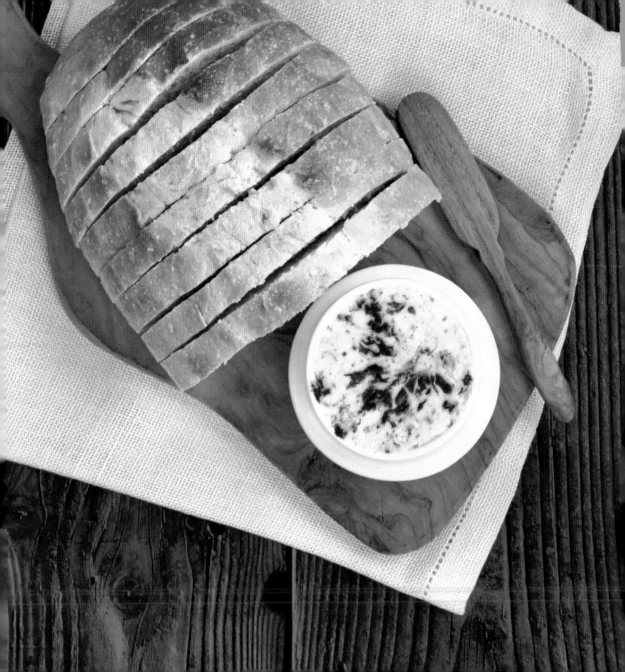

Sun-Dried Tomato and Roasted Garlic Butter

Portion out this tasty butter and freeze up to 3 months. You'll have a readymade topping
for veggies or meats. I usually use the loose, dry tomatoes for this recipe, but oil-packed
is fine if drained well. Roasted garlic makes a wonderful earthy addition to many savory recipes.
Roast a few heads, then save them in the freezer until you want to use them.
I freeze them whole and then thaw before squeezing the pulp into recipes.

makes 1¼ cups

INGREDIENTS
1 head garlic
1 tablespoon extra-virgin olive oil
1 cup salted or unsalted butter,
 softened
⅓ cup sun-dried tomatoes,
 finely chopped
1 tablespoon chopped fresh basil
1 tablespoon chopped
 fresh rosemary
1 tablespoon chopped
 fresh parsley
Salt, to taste

Preheat oven to 400°.

Cut off the top, pointed end of the garlic. Place on a piece of
aluminum foil and drizzle with olive oil. Wrap tightly. Bake
for 30 minutes or until garlic is very tender and dark golden
brown. Let stand until cool enough to handle; squeeze garlic
pulp from cloves into a large bowl.

Combine butter, garlic pulp, tomatoes, basil, rosemary,
and parsley in a bowl, stirring until well blended. Add salt
to taste. Transfer to a crock. Cover and refrigerate up to
3 days, or roll into logs, cover with plastic wrap, and freeze
up to 3 months.

appetizers, breads, and beverages

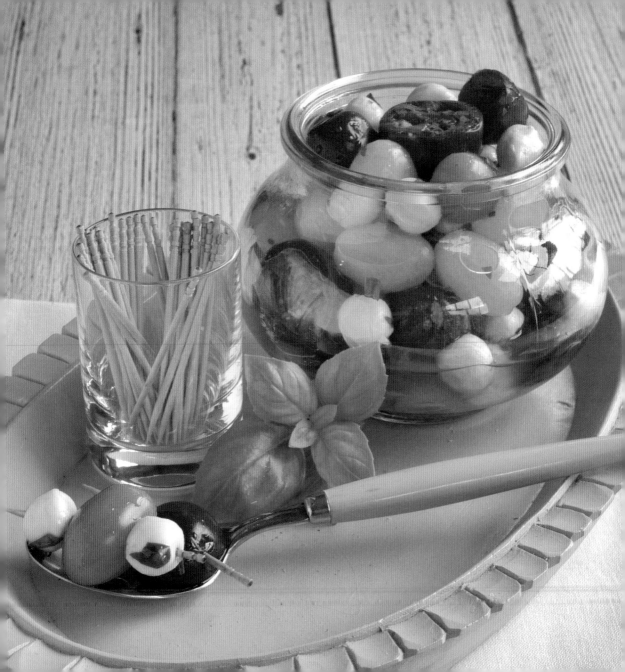

Marinated Cherry Tomatoes

Toss this zesty blend on salads. For parties, serve with wooden picks
on the side or arrange on mini skewers with fresh basil leaves. Keep small,
bite-size tomatoes whole, but cut anything larger than a quarter in half.

makes 5 cups

INGREDIENTS

⅓ cup extra-virgin olive oil
3 tablespoons white balsamic
 or white wine vinegar
1 tablespoon honey
1 large shallot, minced
1 small garlic clove, minced
3 tablespoons chopped
 fresh basil
1 tablespoon minced
 fresh parsley
¼ teaspoon salt
¼ teaspoon grated lemon zest
3 cups (1 pound) mixed cherry
 or grape tomatoes
1 (8-ounce) container fresh
 mozzarella pearls or chopped
 fresh mozzarella

Combine oil, vinegar, honey, shallot, garlic, basil, parsley, salt, and zest in a large bowl.

Stir in tomatoes and mozzarella. Cover and chill for several hours; serve within 3 days.

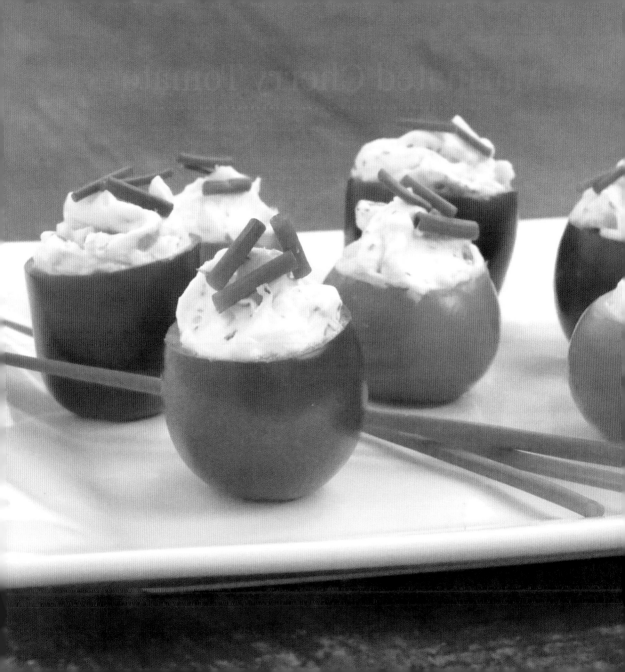

Bacon-and-Basil-Stuffed Cherry Tomatoes

· ·

I can't help planting more cherry tomato plants than my family can actually use.
It's just too tempting to have a few varieties because they can be harvested early and constantly.
Stuff them with this flavorful BLT-inspired filling for something special.
If the cherry tomatoes are large, cut them in half so each one can be eaten in one bite.

· ·

makes 2½ dozen

INGREDIENTS

1 pint cherry tomatoes
4 slices bacon, chopped
(optional)
6 ounces cream cheese, softened
¼ cup (1 ounce) grated fresh
Parmesan cheese
3 tablespoons butter, softened
1 small garlic clove, minced
¼ cup finely chopped fresh basil
½ teaspoon dried dill
½ teaspoon dried
Italian seasoning
⅛ teaspoon lemon zest
⅛ teaspoon coarsely ground
black pepper
1 tablespoon chopped
fresh chives

Cut the stem end from the top of each cherry tomato. Scoop out seeds and discard. Turn upside down on paper towels to drain.

Cook bacon in a skillet over medium heat until crispy. Remove and drain on paper towels.

In a large bowl, combine cream cheese, Parmesan, butter, garlic, basil, dill, Italian seasoning, zest, and pepper, stirring until smooth and well blended. Stir in bacon. Spoon filling into tomatoes. Sprinkle with chopped chives.

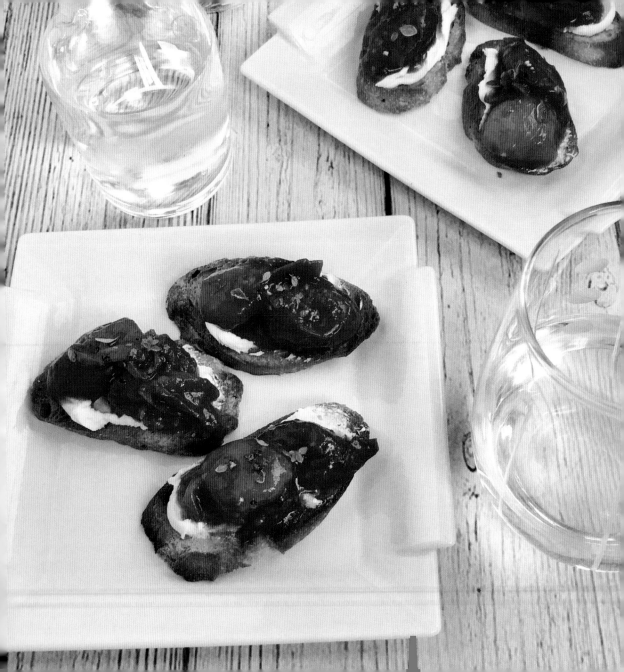

Candied Tomato and Goat Cheese Bruschetta

Here's one of my favorite appetizers to serve to company when the cherry tomato plants are ripening faster than I can use them. The tomato mixture will hold in the refrigerator up to 3 days, but you can halve the recipe if you want less. It's similar to Caponata (page 33) with its sweet and tangy flavor, but it requires less work and fewer ingredients. The flavor goes well with earthy goat cheese, but you can use slivers of brie or even a schmear of cream cheese. Usually a dip like this would make the toasted baguette slices a little soggy, but you can compose some on a platter a bit ahead of time because the cheese serves as a buffer between the sauce and the tender bread.

makes 3½ dozen

INGREDIENTS

1 (10-ounce) French baguette
¼ cup extra-virgin olive oil, divided
1 tablespoon butter
5 cups (about 2 pounds or 2 [12- to 16-ounce containers]) multicolor cherry or grape tomatoes
¼ teaspoon salt
⅛ teaspoon coarsely ground black pepper
¼ cup firmly packed light brown sugar
1 tablespoon balsamic or red wine vinegar
3 to 5 ounces soft goat cheese

GARNISHES

Chopped fresh herbs such as basil, chives, or rosemary

Preheat oven to 375°.

Cut baguette into ¼-inch-thick slices. Place on a baking sheet and brush lightly with all but 1 tablespoon olive oil. Bake for 5 to 8 minutes or until golden brown.

Heat remaining 1 tablespoon olive oil and butter in a large skillet over medium heat. Add tomatoes. Cook, stirring frequently, for 10 minutes or until tomatoes soften and shrink. While tomatoes cook, pierce each one with the tip of a sharp knife. This will speed the cooking process and make a bit of sauce.

Stir in salt, pepper, brown sugar, and vinegar. Cook, stirring occasionally, for 5 to 7 minutes or until any liquid is thick and syrupy.

Spread cheese evenly over toasted bread slices and top evenly with tomato mixture. Garnish, if desired.

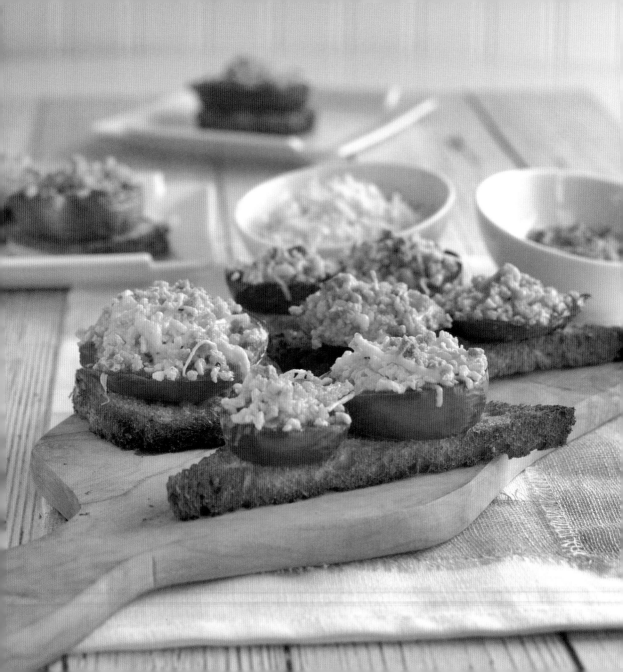

Tomato Toasts
with Pesto and Panko

· ·

You can diagonally slice a baguette, or cut triangles or circles from a slice of sourdough sandwich bread in the same diameter as the tomato. Spoon extra pesto into small zip-top plastic freezer bags or containers; freeze 6 to 9 months, and you'll have fresh pesto anytime.

· ·

makes 8 servings

INGREDIENTS

Pesto Sauce (recipe at right)
 or purchased
½ cup seasoned
 panko breadcrumbs
½ cup (2 ounces) shredded
 Parmesan cheese
¼ teaspoon coarsely ground
 black pepper
3 tablespoons extra-virgin
 olive oil
16 baguette slices or sourdough
 bread triangles or circles
4 large or 8 small (about
 2 pounds) tomatoes

Prepare Pesto Sauce. Cover and refrigerate until ready to use (up to 3 days). Preheat oven to 375°. Combine panko, Parmesan, pepper, and 2 tablespoons oil in a small bowl.

Arrange bread slices in a single layer on a sheet pan. Brush with remaining 1 tablespoon olive oil. Bake slices for 5 to 7 minutes or until golden brown. Remove from pan and set aside.

Cut tomatoes into ¼-inch-thick slices and remove seeds. Place 1 large or 2 small slices on each piece of bread. Dollop each with about 2 teaspoons Pesto Sauce. Sprinkle each with 1 to 2 tablespoons panko mixture.

Bake for 5 minutes or until tomato slices are tender and tops are golden brown.

Pesto Sauce: Combine **1 (4-ounce) container fresh basil, 1 coarsely chopped garlic clove, ½ cup (2 ounces) shredded or grated Parmesan cheese, ½ cup extra-virgin olive oil, ½ teaspoon lemon zest, 1 tablespoon fresh lemon juice**, and **¼ teaspoon salt** in a food processor; pulse until finely chopped. Add **¼ cup toasted walnuts** or **pine nuts**; pulse until finely chopped. Makes 1 cup.

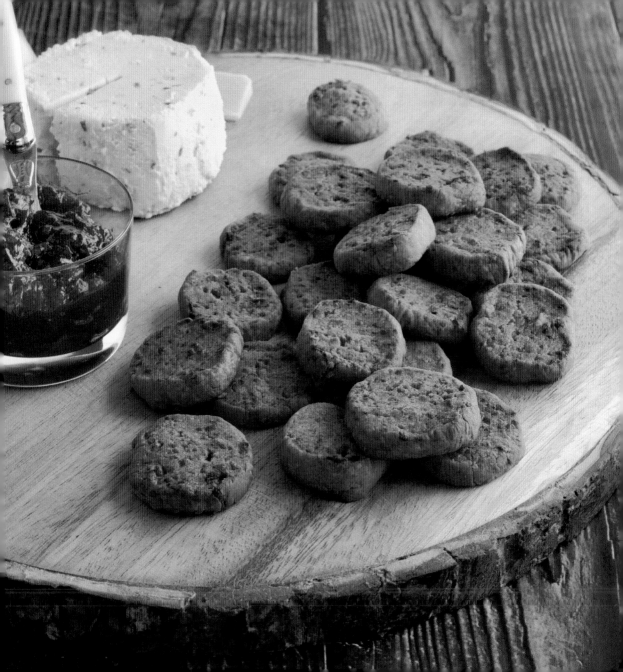

Tomato Shortbread

Fans of cheese straws should try this yummy snack that packs more flavor! For more heat, double the cayenne. You can even make and freeze the dough logs up to 3 months and charm all of your last-minute guests. These make a great addition to fruit and cheese trays.

makes 4½ dozen

INGREDIENTS

1 cup all-purpose or almond flour
½ cup (2 ounces) grated Parmesan cheese
3 tablespoons tomato paste
¼ cup Italian-seasoned sun-dried tomatoes in oil, drained and finely chopped
¼ teaspoon salt
⅛ teaspoon ground cayenne pepper
½ cup (8 tablespoons) cold butter, cut into pieces
1 to 2 teaspoons water

Combine flour, cheese, tomato paste, sun-dried tomatoes, salt, and cayenne in a food processor. Pulse several times until well blended.

Add butter; pulse until dough comes together. If dough is still crumbly, add 1 teaspoon water at a time and process until a dough forms.

Roll dough into 2 (1- to 1¼-inch) logs and cover with plastic wrap. Refrigerate until chilled and firm.

Preheat oven to 350°. Line a baking sheet with nonstick aluminum foil or a silicone baking mat.

Cut logs into ⅛-inch-thick slices. Place 1 inch apart on baking sheet. Bake for 15 minutes or until golden brown. Transfer to a wire rack to cool completely.

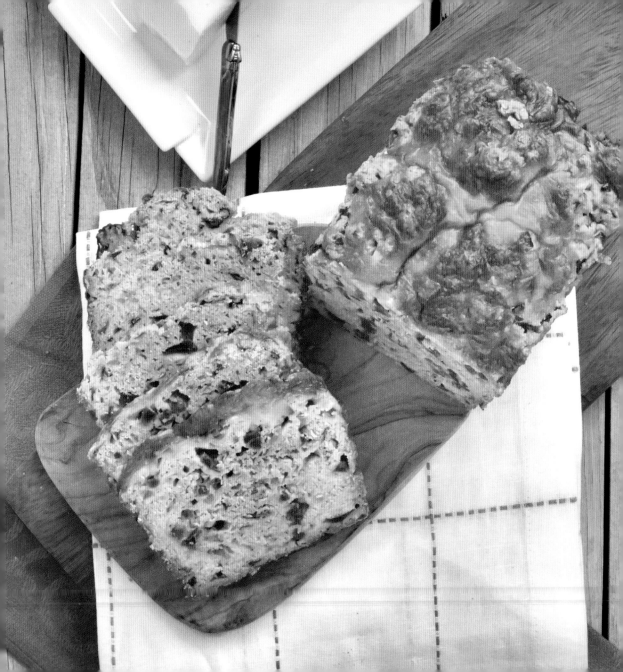

Tomato-Cheddar Quick Bread

You may have made zucchini or banana quick bread dozens of times, but this version featuring fresh tomatoes and cheese makes it a savory favorite. It makes an amazing breakfast toast when heated and slathered with butter. Or try it on the side with a nice warm bowl of tomato soup.

makes 1 (9x5-inch) loaf

INGREDIENTS

3 cups all-purpose flour
1½ teaspoons baking powder
1½ teaspoons baking soda
1 teaspoon salt
½ teaspoon coarsely ground black pepper
2 large eggs
⅓ cup extra-virgin olive oil
½ cup milk
1½ cups (6 ounces) shredded cheddar cheese, divided
1 garlic clove, minced
3 medium-size tomatoes, chopped
¼ cup lightly packed fresh basil leaves, chopped

Preheat oven to 350°. Lightly grease a 9x5-inch loaf pan.

Combine flour, baking powder, baking soda, salt, and pepper in a medium-size bowl.

Combine eggs, oil, and milk in a large bowl. Stir in 1 cup cheese, garlic, tomatoes, and basil. Stir flour mixture into tomato mixture (batter will be sticky and thick). Transfer to prepared loaf pan. Sprinkle with remaining ½ cup cheese.

Bake for 45 minutes or until a wooden skewer inserted in center comes out clean. Cool for 15 minutes on a wire rack, and then remove from pan and cool completely.

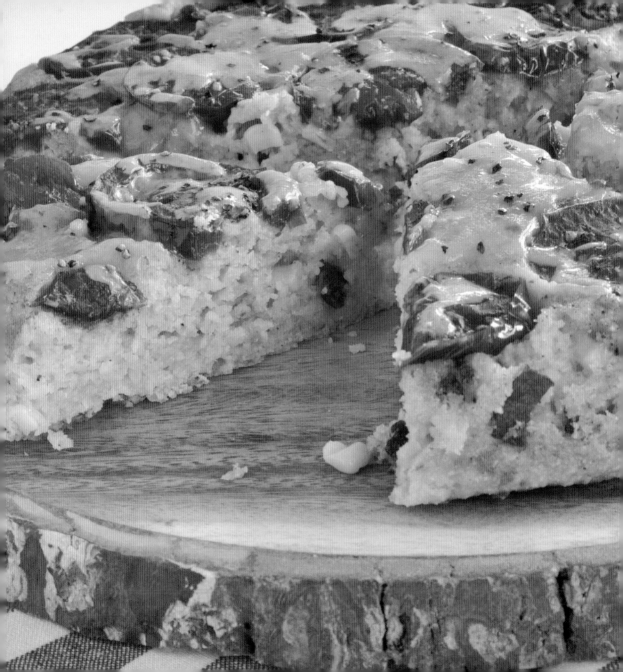

Upside Down Tomato–Bacon Cornbread

• •

A little bit sweet and a lot savory, this cornbread variation is almost a meal.
Spice it up a bit by adding thinly sliced jalapeños with the tomatoes
and stirring ¾ teaspoon ground cumin into the batter.

• •

makes 8 servings

INGREDIENTS

4 slices lean bacon, chopped
½ to ¾ pound (about 3 to 5 small) ripe tomatoes, sliced
1 cup all-purpose flour
1 cup cornmeal
2 tablespoons granulated sugar or brown sugar
1 tablespoon baking powder
½ teaspoon salt
1 large egg
1½ cups buttermilk
6 tablespoons salted or unsalted butter, melted
1 cup fresh or frozen and thawed corn kernels
1½ cups (6 ounces) shredded smoked cheddar or cheddar cheese, divided

Preheat oven to 375°.

Cook bacon in a 10-inch cast iron skillet over medium heat until crispy; remove and drain on paper towels. Arrange tomato slices in bottom of skillet.

Combine flour, cornmeal, sugar, baking powder, and salt in a large bowl. Whisk together egg, milk, and melted butter in a medium-size bowl. Stir milk mixture into flour mixture. Fold in corn kernels, bacon, and 1 cup cheese. Spoon corn mixture over tomatoes.

Bake for 30 minutes or until golden brown and firm. Flip upside down on a plate or platter. Sprinkle with remaining ½ cup cheese and cut into wedges.

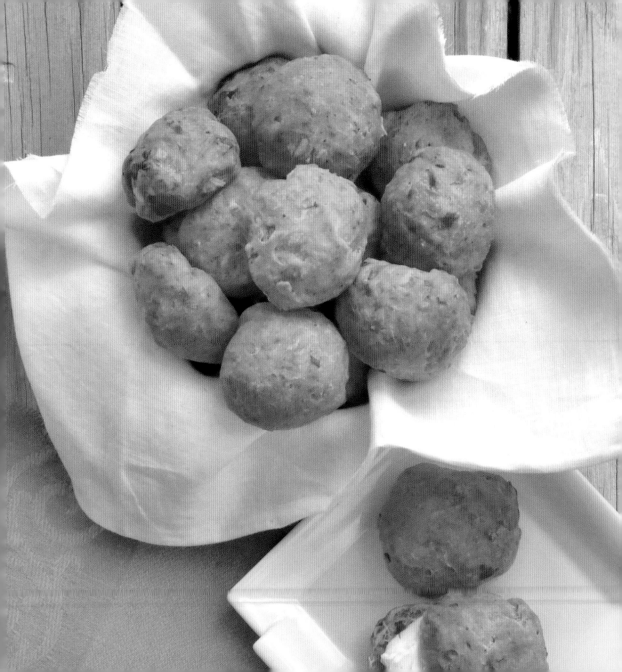

Sun-Dried Tomato-Asiago Rolls

· ·

Make these small rolls for an accompaniment to salads, or double up on the size and make large
(but fewer) rolls you can use for tasty sandwiches. The original recipe came from Kathleen Royal Phillips,
a foodie friend I used to work with when I was in the test kitchen of *Southern Living* magazine. I've changed
it up a little bit over the years, but I want to thank her for introducing me to this flavorful bread idea!

· ·

makes 2 dozen

INGREDIENTS

½ cup sun-dried tomatoes
 (not oil-packed)
1½ cups boiling water
1½ teaspoons active dry yeast
1 tablespoon sugar
⅓ cup extra-virgin olive oil
3 to 3½ cups bread flour,
 divided
2 tablespoons chopped
 fresh chives
1 tablespoon chopped
 fresh rosemary
2 teaspoons salt
1 to 2 teaspoons cracked
 black pepper
1 cup (4 ounces) shredded
 Asiago cheese

Combine tomatoes and 1½ cups boiling water in a large bowl;
let stand for 30 minutes or until tomatoes are tender. Remove
tomatoes, reserving water, and chop. Set aside.

Measure the temperature of the reserved liquid. If cool,
microwave in 10-second increments until it reaches 100° to
110°. Pour into a large mixing bowl. Stir yeast and sugar into
the warm liquid. Let stand for 5 minutes. Stir in olive oil.

Stir in 3 cups flour, tomatoes, chives, rosemary, salt, pepper,
and cheese. Add flour (if needed) to make a very soft dough.

Turn dough out onto a lightly floured surface, and gently
shape it into a ball. Place dough in a large, lightly greased
bowl, turning to grease top. Cover and let rise at room tem-
perature for 2 to 4 hours or until dough has doubled in size.

Punch dough down. Divide into 24 equal pieces, and place
on lightly greased or nonstick aluminum foil-lined baking
sheets. Cover loosely with plastic wrap, and let rise for
30 to 45 minutes or until puffy.

Preheat oven to 350°. Bake for 15 to 20 minutes, rotating
pans if necessary.

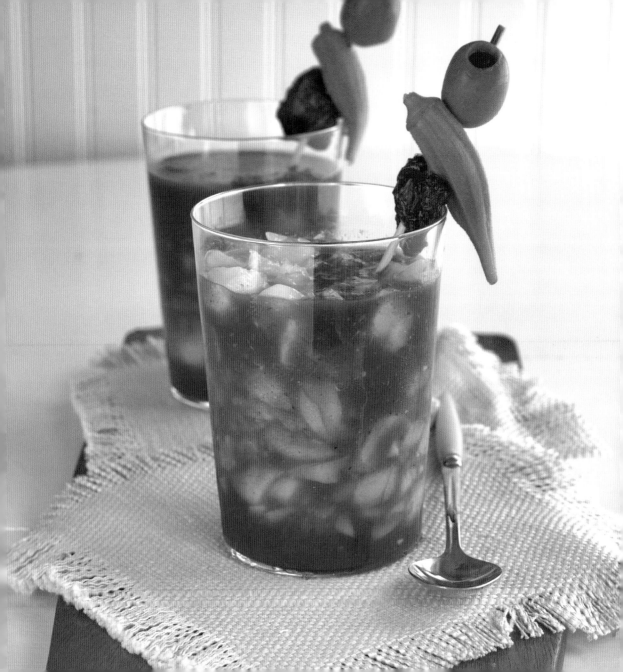

Cajun Bloody Mary

You can tame the heat by using plain vegetable juice, but this version of the quintessential brunch cocktail has a peppery flavor that isn't painful. Serve it simple—or, with enough garnishes, it becomes a meal!

makes 6 cups

INGREDIENTS

4 cups spicy vegetable or tomato juice, chilled

2 tablespoons fresh lime juice

2 tablespoons liquid from a jar of hot pickled okra or pickles

2 tablespoons Cajun seasoning blend

1 tablespoon Worcestershire sauce

1 tablespoon refrigerated prepared horseradish

½ teaspoon celery seeds

¼ teaspoon smoked paprika

1 cup vodka, chilled

GARNISHES

Skewered boiled shrimp, celery slices, cooked bacon, pickled okra, whole olives, or sun-dried tomatoes

Combine vegetable juice, lime juice, okra brine, seasoning blend, Worcestershire, horseradish, celery seeds, smoked paprika, and vodka in a pitcher.

Pour into ice-filled glasses and garnish as desired.

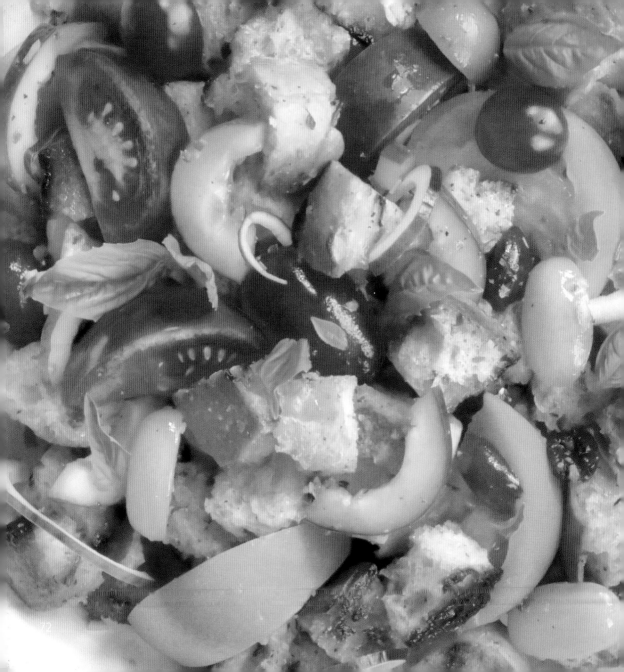

salads

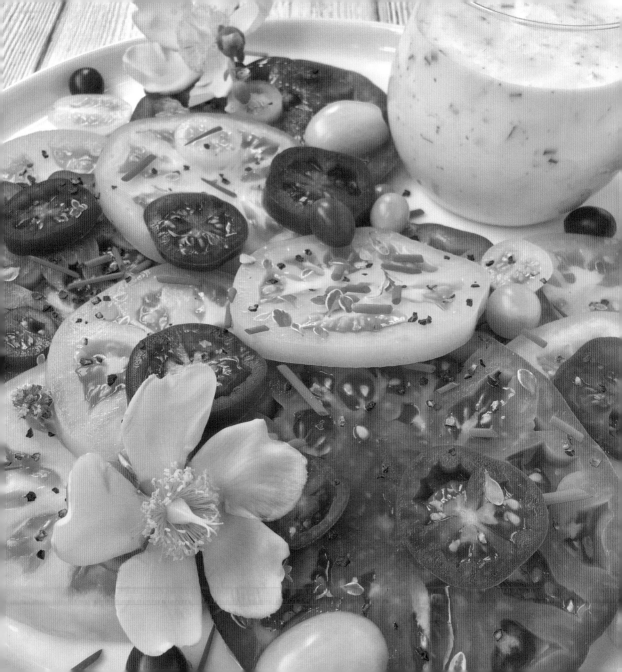

Herbed Buttermilk Dressing and Fresh Tomatoes

Sweet and tangy buttermilk makes the ideal base for a salad dressing with fresh herbs. Large, ripe heirloom tomatoes have an intoxicating aroma, with a balance of sugar and acids that doesn't need much else to make a wonderful summer meal.

makes 1 to 1⅓ cups

INGREDIENTS
½ cup buttermilk
⅓ cup mayonnaise
⅓ cup sour cream
2 tablespoons apple cider vinegar
3 tablespoons chopped fresh basil, thyme, or chives
½ teaspoon salt
½ teaspoon cracked black pepper
¼ teaspoon minced fresh garlic
2 pounds mixed heirloom tomatoes, sliced

To make dressing, combine buttermilk, mayonnaise, sour cream, vinegar, herbs, salt, pepper, and garlic in a bowl, whisking until smooth. Cover and chill until ready to serve. Serve dressing over sliced tomatoes.

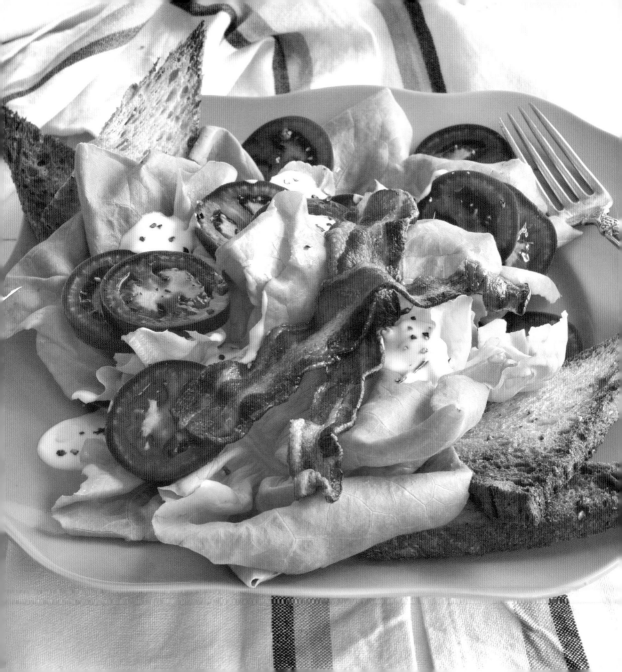

Undone BLT Salad

Bacon, lettuce, and tomato sandwiches are delightful summer treats,
but this deconstructed version is a bit healthier because it includes more lettuce and less bread.

makes 4 servings

INGREDIENTS
Herbed Buttermilk Dressing
 (page 75)
8 to 12 slices bacon
4 to 8 slices sourdough or
 rosemary bread
1 head Bibb lettuce or 1
 (5-ounce) container baby
 spinach or spring greens
1 pound (about 12) small
 tomatoes, sliced
Cracked black pepper

Prepare Herbed Buttermilk Dressing; cover and refrigerate up to 3 days.

Cook bacon in a skillet over medium heat until crispy. Remove and drain on paper towels. Break into pieces, or leave whole.

Remove crusts from bread and cut into triangles. Toast in a toaster oven until golden brown. (If using a regular toaster, leave whole and then cut.)

Arrange lettuce and tomatoes on a serving platter or individual plates. Top with bacon and bread. Drizzle with dressing and sprinkle with pepper.

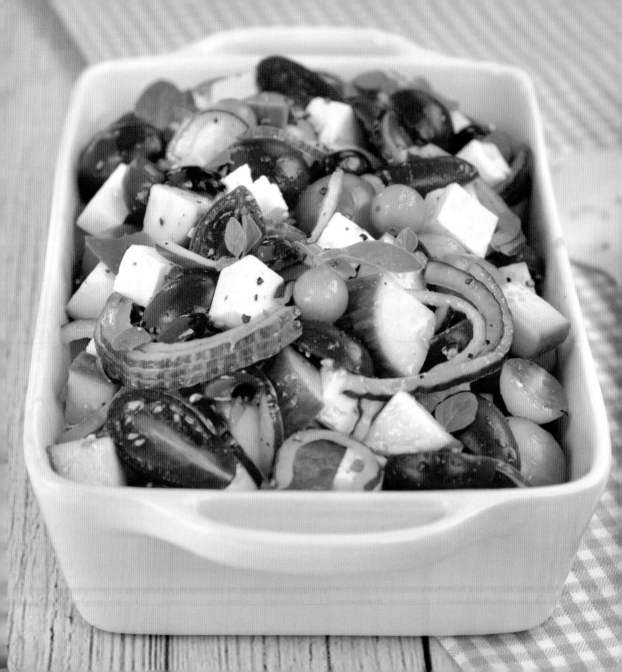

Greek Tomato Salad

This recipe makes more than enough vinaigrette to marinate the tomatoes, cucumber, and other ingredients. You can level up this side salad to an entrée by serving it over a pile of salad greens and adding a few cups of shredded chicken.

makes about 8 cups

INGREDIENTS

2 tablespoons chopped fresh or
　½ teaspoon dried oregano
2 tablespoons red wine vinegar
2 tablespoons fresh lemon juice
2 small garlic cloves, minced
½ teaspoon salt
¼ teaspoon coarsely ground
　black pepper
½ cup extra-virgin olive oil
1 pound multicolor cherry or
　grape tomatoes, halved
1 cucumber, quartered and sliced
½ small red onion, thinly sliced
⅓ cup kalamata olives, halved
1 cup (4 ounces) feta cheese,
　cubed or crumbled

To make vinaigrette, combine oregano, vinegar, lemon juice, garlic, salt, and pepper in a large bowl. Whisk in olive oil.

Stir in tomatoes, cucumber, onion, and olives. If the feta is cut into large cubes, gently stir it into the mixture. If the feta is crumbled, sprinkle it on top of the salad.

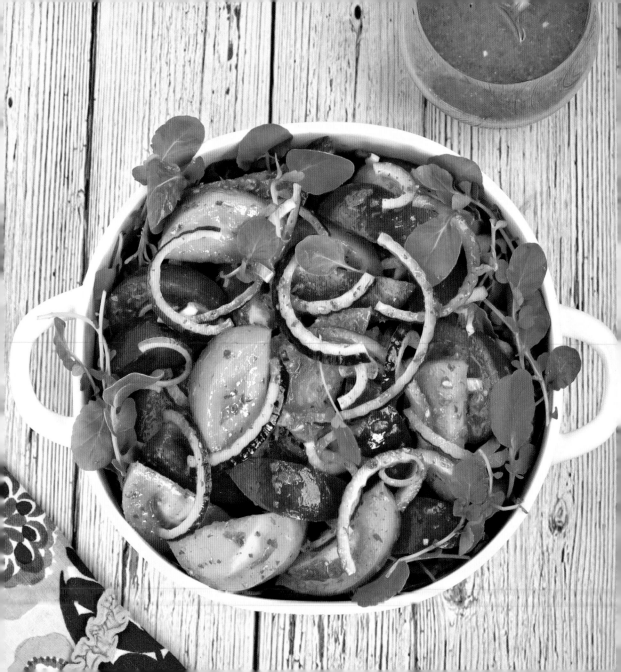

Tomato-Watercress Salad with Chimichurri Vinaigrette

Watercress is a spicy, pungent green. It has loads of nutritional value like other cruciferous vegetables such as arugula, kale, and broccoli. Look for baby watercress—older or mature watercress can taste bitter. Here, I tried to recreate a tomato-watercress salad from my favorite Argentinian restaurant. It has a simple vinaigrette dressing, but I couldn't resist adding more flavor with my favorite steak topping—chimichurri. Make it an entrée by adding slices of grilled skirt steak.

makes 4 servings

INGREDIENTS

Chimichurri Vinaigrette
 (recipe at right)
3 large tomatoes (about 1½
 pounds), cut into wedges
½ small red onion,
 very thinly sliced
1 (4-ounce) bag fresh watercress
 or baby arugula

Prepare Chimichurri Vinaigrette. Cover and chill until ready to serve.

Combine tomatoes and onion in a large bowl. Drizzle in about ½ cup of the vinaigrette; toss until coated. Arrange tomatoes and onion over watercress on a serving platter or individual plates. Serve with additional vinaigrette on the side.

Chimichurri Vinaigrette: Combine **1 cup lightly packed fresh Italian parsley leaves, 1 tablespoon fresh oregano leaves or ½ teaspoon dried oregano, 2 garlic cloves (minced), ¼ teaspoon fresh lime zest, 2 tablespoons fresh lime juice, 2 tablespoons red wine vinegar, 2 tablespoons water, 1½ teaspoons ground cumin, 1 teaspoon chili powder, 1 teaspoon salt, 1 teaspoon sugar, ¼ teaspoon crushed red pepper flakes, and ½ cup olive oil** in a blender. Process until parsley is very finely chopped. Makes 1 cup.

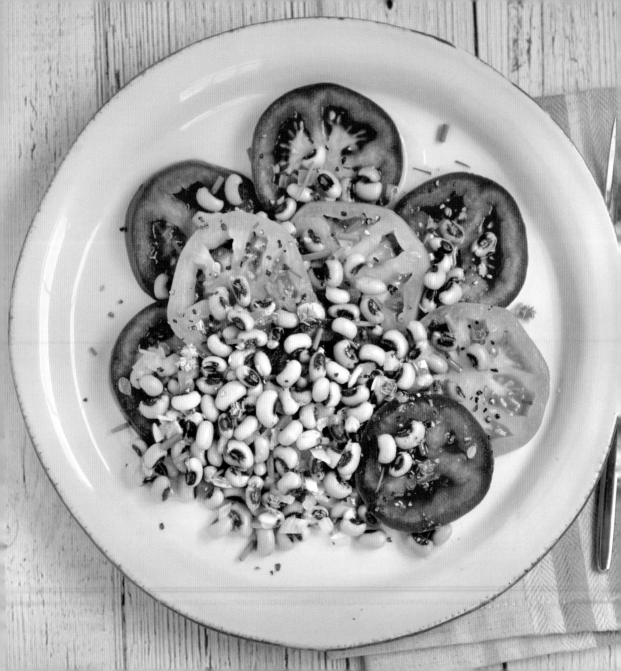

Tomato and Black-eyed Pea Salad

Tomatoes and black-eyed peas pair well together. Peak tomato season is summer,
and I'm not fond of heating up the kitchen cooking dried peas, so I go for canned.
What makes this dish so wonderful—aside from its bright, fresh flavor—is its adaptability.
Swap out your favorite bean or other cooked vegetable for the black-eyed peas—
try black beans, garbanzo beans, or even corn kernels.

makes 4 servings

INGREDIENTS

½ cup olive oil
½ teaspoon lemon zest
¼ cup fresh lemon juice
2 small garlic cloves, minced
½ to 1 jalapeño, seeded
 and minced
1 tablespoon minced
 sweet onion
1 tablespoon chopped fresh
 basil, oregano, thyme,
 or a mix
½ teaspoon salt
¼ teaspoon coarsely ground
 black pepper
2 (15.5-ounce) cans black-eyed
 peas, rinsed and drained
2 pounds large heirloom
 tomatoes, sliced

Whisk together olive oil, lemon zest, lemon juice, garlic, jalapeño, onion, fresh herbs, salt, and pepper in a large bowl.

Stir in black-eyed peas, tossing gently. Cover and chill for several hours to allow the flavors to marry.

Place tomatoes on a serving platter or individual plates; top evenly with black-eyed pea mixture.

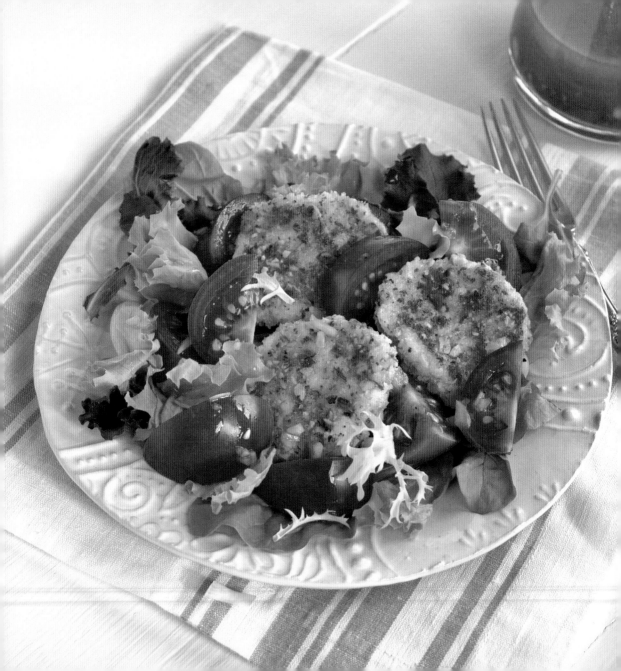

Mixed Heirlooms with Walnut-crusted Fried Goat Cheese

Ripe tomatoes paired with walnuts and goat cheese create a delightful umami experience!
Smaller tomatoes are easy to serve cut into wedges, with the smaller bites fitting easily on a fork.

makes 4 servings

INGREDIENTS

Sherry-Walnut Vinaigrette
 (recipe at right)
⅓ cup all-purpose flour
1 large egg, lightly beaten
1 teaspoon water
½ cup seasoned
 panko breadcrumbs
½ cup finely chopped walnuts
¼ teaspoon salt
1 (10.5-ounce) package fresh
 goat cheese
2 tablespoons olive oil
8 cups baby spring greens or
 torn Romaine
6 small yellow or red heirloom
 tomatoes, cut into wedges

Prepare vinaigrette; cover and refrigerate until ready to assemble the salad. Place flour in a shallow bowl. Combine egg and water in another shallow bowl. Combine breadcrumbs, walnuts, and salt in a third shallow bowl.

Cut goat cheese into 12 rounds. Coat each goat cheese patty in flour, dip in egg mixture, then dredge on all sides in walnut mixture. Place rounds on a wax paper-lined baking sheet and freeze for 30 minutes.

Heat oil in a large nonstick skillet over medium-high heat. Cook cheese rounds, in batches, for 1 minute on each side or until golden brown. Place lettuce and tomatoes on a serving platter or individual plates; top with cheese rounds and serve with vinaigrette.

Sherry-Walnut Vinaigrette: **Combine ⅓ cup sherry vinegar, ½ teaspoon Dijon mustard, 1 small shallot (minced), ½ teaspoon salt, ¼ teaspoon coarsely ground black pepper, ⅓ cup walnut oil, and ¼ cup extra-virgin olive oil** in a jar; cover tightly, and shake until well blended. Cover and store in the refrigerator until ready to serve, up to 1 week. Makes 1 cup.

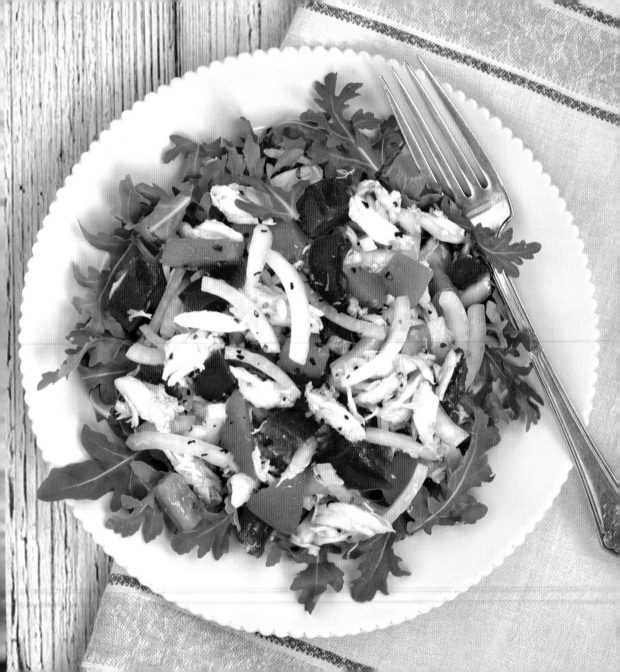

Tomato-Crab Salad

This is a riff on West Indies Salad—a simple crab-and-onion dish that usually contains a bit of ice water. The tomatoes and onions will water out a bit, so I find there's no need to dilute the vinaigrette. I encourage using sweet onions that are mild and easy to eat raw. You can use yellow or white onions, but I suggest soaking them in ice water for 15 minutes to remove some of the harsh bite.

makes about 6 cups

INGREDIENTS

1 pound ripe tomatoes, seeded and chopped
½ large sweet onion, sliced or chopped
½ cup mild-flavored extra-virgin olive oil
½ cup apple cider vinegar
1 teaspoon salt
1 teaspoon cracked or coarsely ground black pepper
1 pound lump crabmeat, drained and picked

Combine tomatoes, onion, oil, vinegar, salt, and pepper in a large bowl. Add crabmeat, folding gently to blend. Cover and refrigerate until chilled.

Serve alone or over baby arugula or other fresh salad greens.

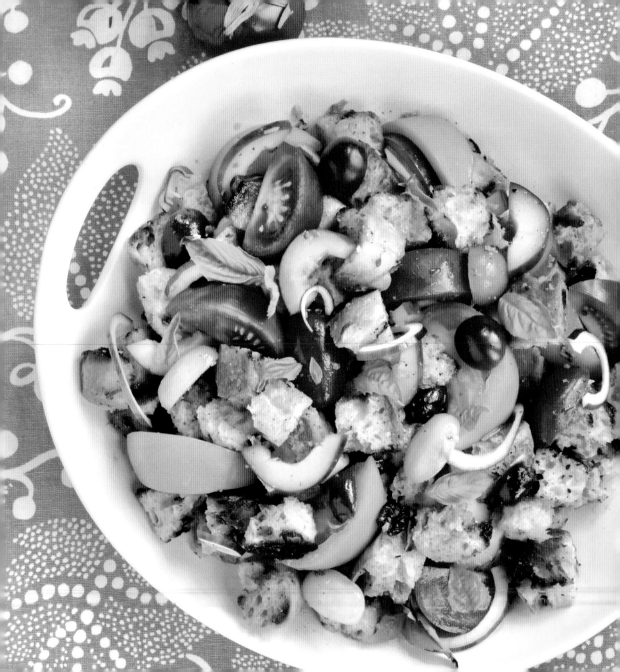

Grilled Panzanella Salad

This salad gets more interesting when you use a highly flavored artisan bread.
Some common ones found at bakeries or delis include rosemary-sea salt or olive bread.
The hearty dish is traditionally made with stale bread so it won't get soggy.
You can speed the process and add a touch of smoky flavor by grilling the bread to get it crisp.

makes 6 to 8 servings

INGREDIENTS

½ (14- to 16-ounce) loaf
 artisan bread
¾ cup extra-virgin olive oil,
 divided
2½ to 3 pounds mixed types
 of tomatoes, cut into wedges
 or halved
¼ small sweet or red onion,
 quartered and thinly sliced
½ cucumber, peeled, halved,
 seeded and sliced
⅓ cup kalamata olives, halved
 or sliced
½ cup lightly packed fresh basil
 leaves, chopped
⅓ cup sherry or red
 wine vinegar
1 garlic clove, minced
1 teaspoon minced
 fresh rosemary
1 teaspoon salt
1 teaspoon coarsely ground
 black pepper

Preheat grill to medium-high heat. Cut bread into ¾-inch thick slices. Brush bread on both sides with olive oil (about ¼ cup total). Grill bread for 2 to 3 minutes on each side or until toasted. Cut bread into cubes.

Place bread cubes, tomatoes, onion, cucumber, olives, and basil in a large bowl.

To make vinaigrette, whisk together remaining ½ cup olive oil, sherry vinegar, garlic, rosemary, salt, and pepper. Drizzle vinaigrette over bread and tomato mixture, tossing well.

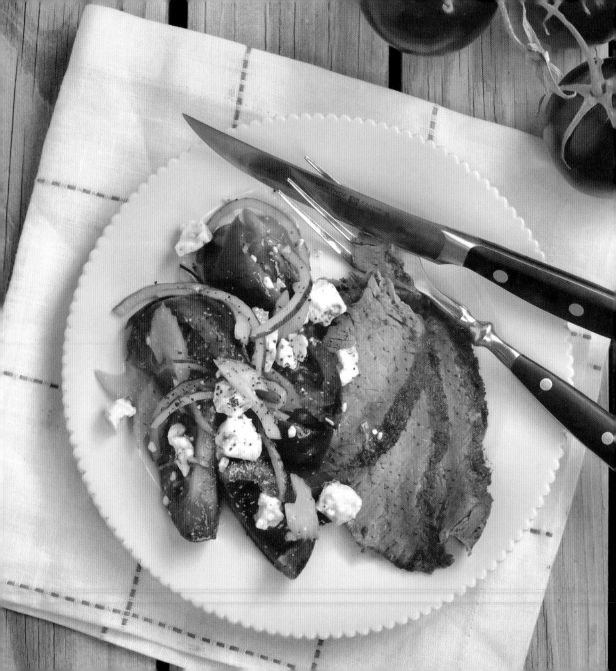

Beefsteak Tomato, Beef Steak, and Blue Cheese Salad

Season the steak with your favorite homemade or purchased seasoned salt blend.
I add smoked paprika for a warm, earthy flavor. For an entrée salad, serve
the steak and tomatoes over 1½ to 2 cups of greens per person.

makes 4 servings

INGREDIENTS

1 (1-pound) flank or other
 beef steak
1 tablespoon smoke- or garlic-
 flavored seasoned salt
⅓ cup extra-virgin olive oil
¼ cup champagne or white
 wine vinegar
1 teaspoon sugar
½ teaspoon Dijon mustard
½ teaspoon salt
¼ teaspoon coarsely ground
 black pepper
3 large beefsteak or
 4 medium-size tomatoes
2 celery stalks, thinly sliced
¼ small red onion,
 very thinly sliced
½ cup crumbled blue cheese

Trim the flank steak and rub top and bottom with seasoned salt (cover and dry marinate several hours—or overnight, if desired).

Heat the grill or grill pan to medium-high heat. Brush the grill grate with oil. Grill the steak 5 minutes on each side. Let stand 15 minutes before slicing.

Meanwhile, to make vinaigrette, whisk together ⅓ cup olive oil, vinegar, sugar, mustard, salt, and pepper in a small bowl. Set aside.

Cut the tomatoes into wedges; remove cores. Place in a bowl with celery and onion. Drizzle with vinaigrette, tossing gently to coat. Add blue cheese, and toss gently. Serve tomato mixture over steak.

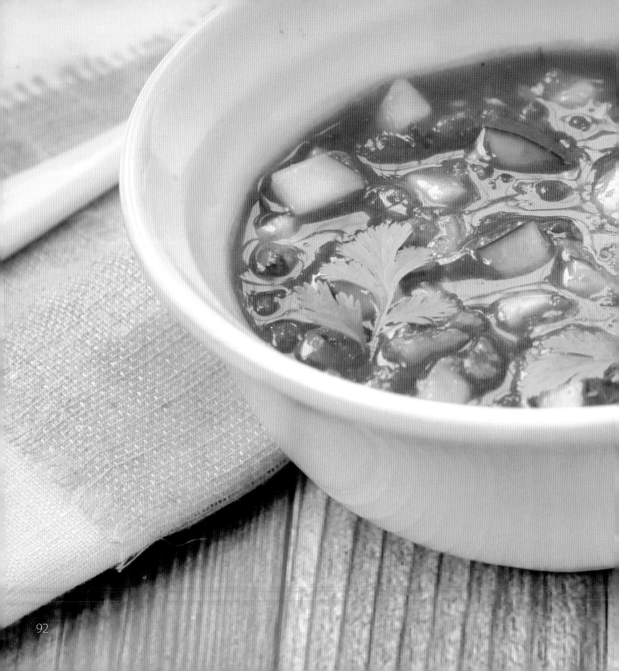

soups

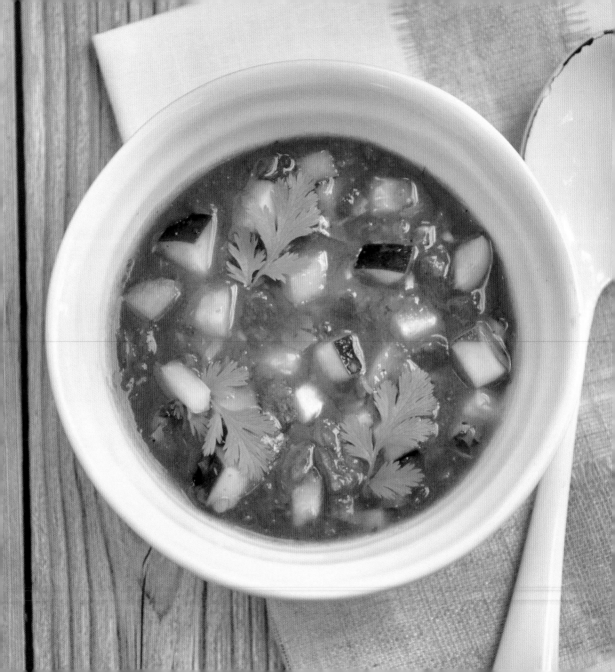

Garden Gazpacho

Pieces of fresh veggies ramp up the flavor, texture, and nutrition in this easy chilled soup. Make a big batch as a refreshing summer side—it'll keep for a few days in the refrigerator.

makes 8 cups

INGREDIENTS

2 cups vegetable juice
¼ cup fresh lemon juice
2 tablespoons
 Worcestershire sauce
2 tablespoons
 prepared horseradish
2 tablespoons extra-virgin
 olive oil
2 pounds heirloom or beefsteak
 tomatoes, coarsely chopped
¼ small red onion, chopped
½ cup packed cilantro leaves
2 garlic cloves, coarsely chopped
2 teaspoons salt
¾ teaspoon coarsely ground
 black pepper
1 jalapeño, seeded and minced
 (optional)
1 yellow bell pepper,
 finely chopped
1 zucchini, finely chopped
1 small cucumber, seeded
 and chopped

Combine vegetable juice, lemon juice, Worcestershire, horseradish, olive oil, tomatoes, onion, cilantro, garlic, salt, and pepper in a food processor. Process until mixture is finely chopped. Transfer to a bowl.

Stir in the jalapeño, bell pepper, zucchini, and cucumber. Cover and chill for several hours or overnight.

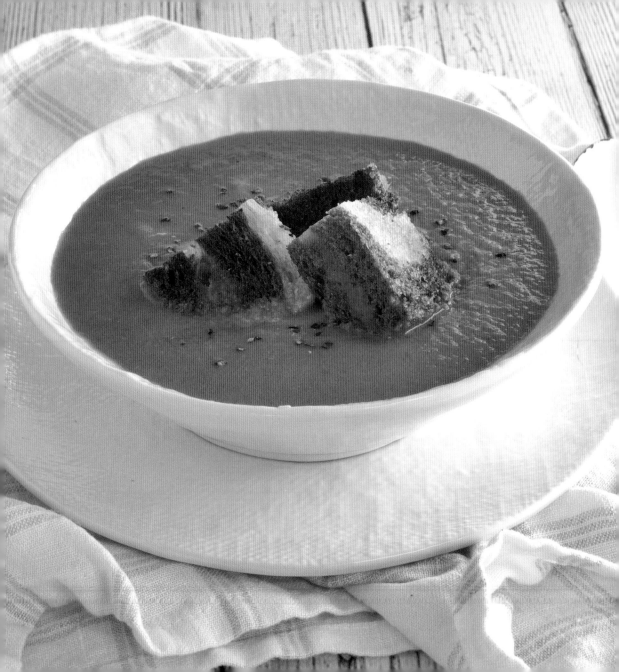

Fresh Tomato Bisque

Warm and creamy tomato soup is one of the ultimate comfort foods, and a grilled cheese sandwich makes the perfect pairing. Serve one on the side, or cut one into cubes to make chunky croutons. Sometimes fresh tomato soups can be too harsh or sour. A pinch of baking soda not only neutralizes the acid, but it also helps prevent curdling when the cream or milk is added.

makes 8 cups

INGREDIENTS

4 tablespoons butter, divided
1 small sweet onion,
 finely chopped
1 carrot, peeled and
 finely chopped
2 celery stalks, finely chopped
2 tablespoons all-purpose flour
4 cups vegetable or chicken broth
4½ pounds (about 6 large) ripe
 tomatoes, seeded
 and chopped
1 teaspoon sugar
1 teaspoon salt
½ teaspoon coarsely ground
 black pepper
⅛ teaspoon baking soda
 (optional)
½ cup heavy cream
Grilled cheese sandwiches,
 cut into cubes

Melt butter in a large soup pot over medium heat. Add onion, carrot, and celery. Cook, stirring frequently, for 5 to 7 minutes or until vegetables are tender.

Add flour. Cook, whisking constantly, for 1 minute. Add broth, whisking until smooth. Stir in tomatoes, sugar, salt, and pepper.

Bring to a boil, reduce heat, and simmer for 30 minutes. Puree soup with an immersion blender.

Remove from heat. Stir in baking soda. Stir in cream. Top each serving with grilled cheese sandwich cubes.

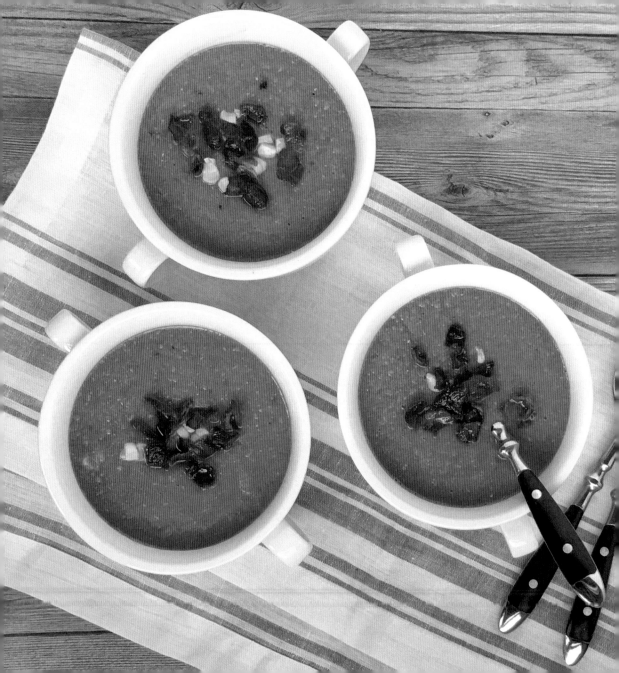

Roasted Tomato-and-Corn Soup

Although the corn and tomatoes are roasted, it's the chipotle peppers that add a rich, smoky flavor to this plentiful soup. Add a bit more if you like spicy foods.

makes 11 cups

INGREDIENTS

4 pounds (about 6 large) tomatoes, halved
2 cups fresh corn kernels (about 3 cobs)
1 tablespoon olive oil
4 slices bacon, chopped
½ large sweet onion, chopped
3 garlic cloves, minced
1½ teaspoons chopped chipotle peppers in adobo sauce
½ teaspoon ground cumin
½ teaspoon chili powder
1 teaspoon salt
4 cups chicken broth

Preheat broiler. Line 2 sheet pans with aluminum foil.

Place tomatoes and corn evenly on prepared pans. Drizzle with olive oil, stirring slightly to coat corn. Broil for 5 to 7 minutes, rotating pans if necessary, until corn is slightly browned and tomatoes are soft. (Set aside a few corn kernels for garnish, if desired.)

Cook bacon in a stockpot over medium heat until crispy. Remove with a slotted spoon; set aside. Add onion to drippings. Cook, stirring frequently, over medium-high heat for 5 minutes or until tender. Stir in garlic, chipotle peppers, cumin, chili powder, and salt. Cook for 3 minutes. Stir in broth, corn, tomatoes, and any liquid from sheet pan. Bring to a boil, reduce heat to medium, and cook for 15 minutes, stirring occasionally.

Blend mixture with an immersion blender until smooth (or transfer to a blender in batches and puree until smooth). Ladle soup into bowls, and garnish with bacon, a sprinkle of chili powder, and reserved corn kernels, if desired.

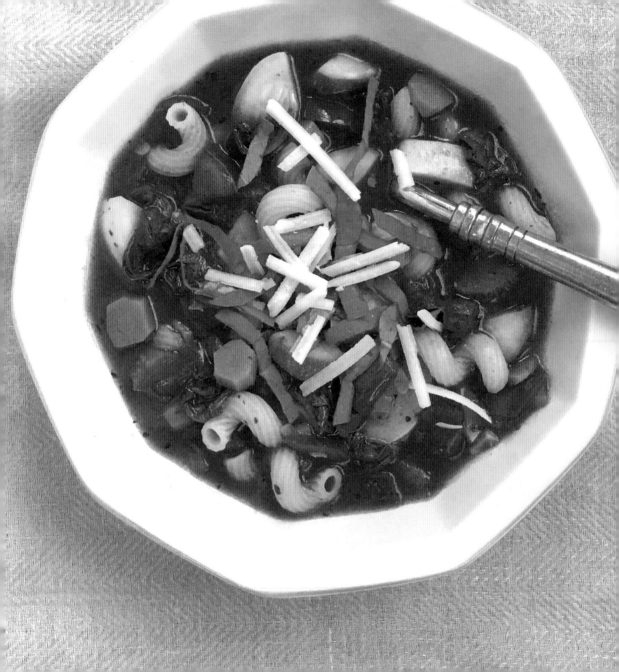

Summer Vegetable Minestrone

This garden-centric soup features the best of summer, but you can also substitute equivalent amounts (about 3 cups) of winter squash, such as butternut, allowing a few extra minutes for the squash to get mostly tender before adding the pasta. If desired, substitute 1 (28-ounce) can seasoned diced tomatoes (undrained) for fresh.

makes 8 cups

INGREDIENTS

2 tablespoons extra-virgin
 olive oil
1 medium-size onion, chopped
2 carrots, peeled and chopped
2 celery stalks, chopped
3 garlic cloves, minced
1½ teaspoons dried
 Italian seasoning
⅛ teaspoon red pepper flakes
1 teaspoon salt
¼ teaspoon coarsely ground
 black pepper
1 zucchini, quartered and sliced
1 yellow squash, quartered
 and sliced
4 cups vegetable or chicken broth
1½ pounds (about 6 to 8) plum or
 other ripe tomatoes, peeled (if
 desired), seeded, and chopped
¼ cup tomato paste
1 cup macaroni or other
 small pasta
2 cups baby spinach
1 tablespoon chopped fresh basil
Freshly grated Parmesan cheese

Heat oil in a Dutch oven or soup pot over medium heat. Add onion, carrots, celery, garlic, Italian seasoning, red pepper flakes, salt, and pepper. Cook, stirring frequently, for 5 to 7 minutes or until vegetables are tender. Add zucchini and yellow squash. Cook for 3 minutes or until squash is halfway cooked.

Stir in broth, tomatoes, and tomato paste. Bring mixture to a boil and stir in pasta. Reduce heat and gently simmer, stirring occasionally, for 10 minutes or until pasta and squash are tender. Stir in spinach and basil. Cook, stirring gently, until spinach wilts. Top each serving with Parmesan cheese.

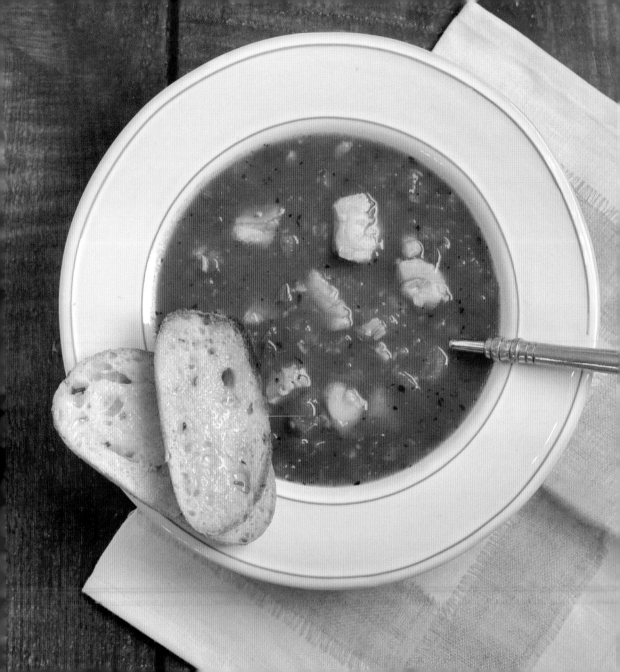

Manhattan Fish Chowder

Manhattan-style chowders differ from New England versions with the addition of tomatoes
(and sometimes flour) and a lack of cream. Fennel adds a subtle anise flavor,
but there's an option for celery that is milder yet adds a similar crunch.

makes 6 servings

INGREDIENTS

- 1 tablespoon extra-virgin olive oil
- 4 red potatoes, peeled and chopped
- 1 medium-size onion, chopped
- 1 medium-size fennel bulb or 3 celery stalks, chopped
- 1 medium-size red bell pepper, chopped
- 2 garlic cloves, minced
- ¼ teaspoon red pepper flakes
- ½ cup dry white wine
- 1 (28-ounce) can crushed tomatoes in puree
- 1½ teaspoons dried Italian seasoning
- ½ teaspoon salt
- 2 cups low-sodium chicken broth
- 1 (8-ounce) bottle clam juice, or seafood or vegetable broth
- 1 pound boneless, skinless firm white fish, cut into pieces

Heat oil in a large Dutch oven or soup pot over medium heat. Add potatoes, onion, fennel, bell pepper, garlic, and red pepper flakes. Cook, stirring constantly, for 5 minutes.

Stir in wine; cook 1 minute. Stir in tomatoes, seasoning, salt, broth, and clam juice. Bring to a boil, reduce heat, and simmer, covered, for 15 minutes or until potatoes are tender.

Add fish; cover and cook until opaque, about 5 minutes. Serve immediately.

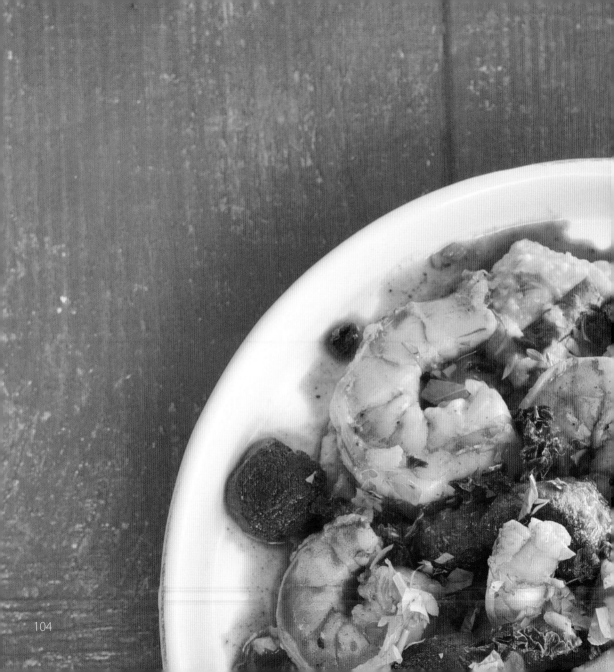

sides and entrées

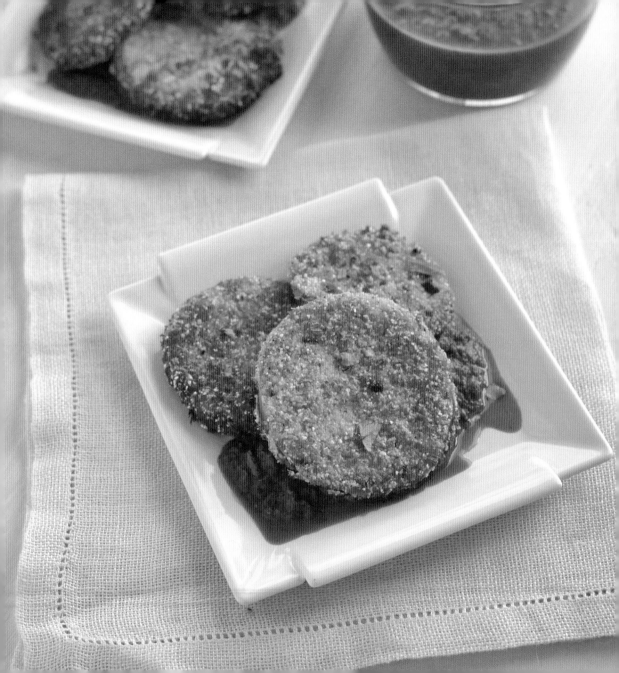

Fried Green Tomatoes

I really can't express how much I love fried green tomatoes. Many recipes use only cornmeal
or a bread batter. I like the crispy crunch of cornmeal, but I need a bit of breadcrumbs
to soften the texture. If your tomatoes are very hard, slice them thinner so they can cook
to tender before overbrowning. You'll get more slices and therefore use up more of the batter.
I also use pink tomatoes—the ones just starting to ripen—because they are still tangy and firm.

makes about 2 dozen

INGREDIENTS

6 small to medium-size
(2 pounds) green or
pink tomatoes
1 tablespoon Cajun seasoning
blend or seasoned salt
1 cup all-purpose flour
2 teaspoons garlic powder
2 large eggs
½ cup buttermilk or milk
¾ cup cornmeal
¾ cup seasoned panko or
dry breadcrumbs
Canola or vegetable oil
Grated or shredded
Parmesan cheese
Salt (optional)
Roasted Tomato Romesco Sauce
(page 45)

Remove cores from tomatoes and cut into ¼-inch-thick slices.
Sprinkle both sides evenly with seasoning blend.

Stir together flour and garlic powder in a shallow bowl.
Whisk together eggs and buttermilk in a shallow bowl.
Stir together cornmeal and panko in another shallow bowl.

Pour oil into a deep cast iron or heavy skillet to a depth of
¼ to ½ inch. Heat to 350° to 375°.

Dredge tomato slices first in flour mixture. Dip in egg mixture
and then dredge in cornmeal mixture.

Fry tomatoes, in batches, in hot oil for 2 minutes on each
side or until golden brown. Cool slightly on paper towels to
absorb excess oil. Sprinkle with additional seasoning blend,
grated Parmesan cheese, and, if desired, salt. Serve with
Roasted Tomato Romesco Sauce.

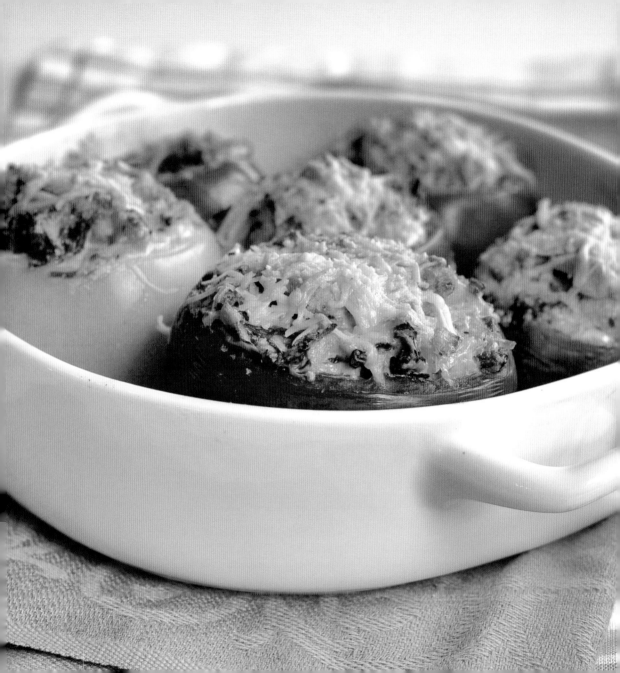

Creamed Spinach-and-Artichoke-Stuffed Tomatoes

If you enjoy hot spinach-artichoke dip, try this interesting stuffed tomato. The spinach mixture makes about 2 cups, so use that amount to figure out how many tomatoes you'll need. The smaller tomatoes on the vine that you see at markets can hold ¼ to ⅓ cup each.

makes 6 servings

INGREDIENTS

6 medium-size (about 2 pounds) ripe tomatoes
2 tablespoons butter
¼ small sweet or yellow onion, finely chopped
3 garlic cloves, minced
1 (10-ounce) container baby spinach leaves
2 ounces cream cheese, room temperature and cut into pieces
½ cup half-and-half, cream, or milk
¼ cup (1 ounce) grated or shredded Romano or Parmesan cheese, divided
¼ teaspoon salt
1 (14-ounce) can whole or quartered artichokes, drained and chopped
1 tablespoon Italian-seasoned breadcrumbs

Preheat oven to 375°. Butter an 8x8-inch baking dish. Cut about ¼ inch from the top of each tomato. Scoop out seeds and any gel or liquid. Turn upside down while preparing the remaining recipe.

Melt 2 tablespoons butter in a large skillet over medium heat. Add onion and cook, stirring frequently, for 3 to 5 minutes or until tender. Stir in garlic; cook for 1 minute.

Stir in spinach. Cook, tossing frequently with tongs, for 3 to 5 minutes or until spinach wilts. Add cream cheese, half-and-half, 2 tablespoons Romano, and salt. Cook, stirring constantly, for 2 minutes or until cheese is melted and mixture is smooth. Stir in artichokes.

Spoon spinach mixture evenly into tomatoes and place in prepared baking dish. Sprinkle with remaining 2 tablespoons cheese and breadcrumbs.

Bake for 25 minutes or until golden brown and thoroughly heated.

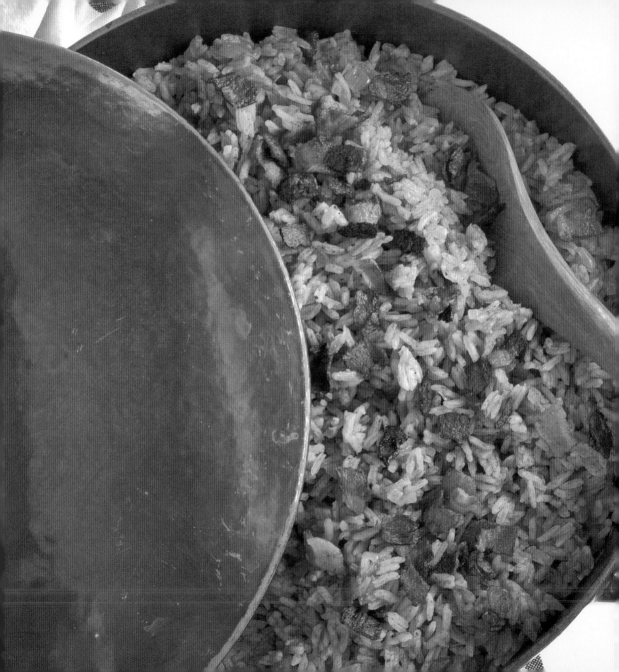

Simple Stovetop Red Rice

Many cultures have a variation of this easy rice dish where rice is cooked with tomatoes.
This one is seen a lot in the Lowcountry, especially in South Carolina.
My dear friend Rebecca grew up with a similar version that her mom, Shirley Bull,
put on the table alongside fried freshwater fish. I prefer the ease of baking the side dish
in the oven so I don't have to fret about scorching the bottom. You can add ½ cup chopped green
bell pepper and ½ cup chopped celery and remove one of the onions as another veggie-centric option.

makes 6 servings

INGREDIENTS

4 strips bacon, chopped
2 small yellow onions,
 finely chopped
¼ teaspoon crushed red pepper
 flakes (optional)
2 cups uncooked long-grain rice
2 cups chicken or vegetable
 broth or water
1½ cups Insta-fresh
 Tomato Sauce (page 39) or
 2 (8-ounce) cans tomato sauce
1 to 2 teaspoons salt
¼ teaspoon coarsely ground
 black pepper
1 teaspoon sugar

Preheat oven to 350°.

Cook bacon in a large ovenproof, deep skillet or cassoulet pan over medium heat until crispy. Remove bacon, reserving about 1 tablespoon drippings in bottom of skillet. Add onions and, if desired, red pepper flakes. Cook over medium heat, stirring frequently, for 5 minutes or until onions are translucent but not browned. Add rice. Cook, stirring constantly, for 3 minutes or until slightly translucent.

Stir in broth, sauce, salt, pepper, and sugar. Bring to a boil and remove from heat. Cover and bake for 30 minutes or until rice is tender. Fluff with a fork and sprinkle with crumbled bacon.

Note: If desired, instead of baking, you can continue to cook, covered, on the stove for 20 minutes on medium-low heat or until rice is tender. Fluff with a fork and sprinkle with crumbled bacon.

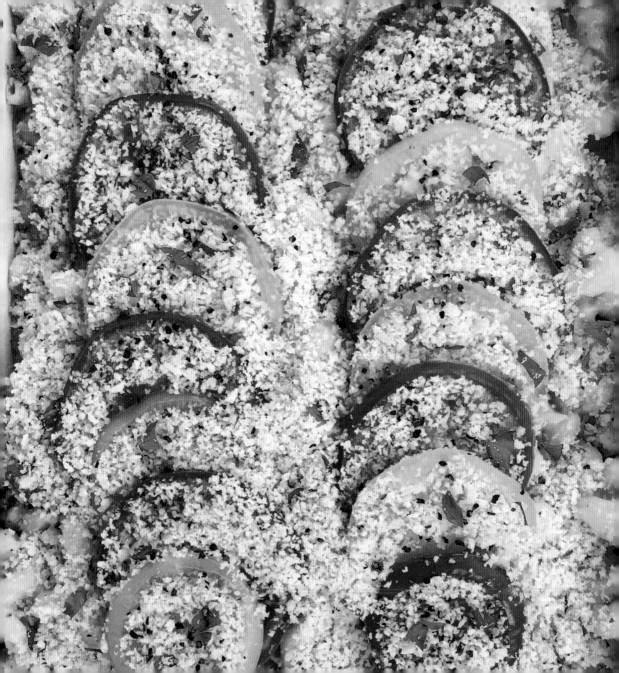

Tomato Mac 'n' Cheese

Tomato lovers will adore this pasta side dish that is hearty enough to be a main dish.
The crispy topping adds an addictive crunch that only enhances the creamy casserole.

makes 10 to 12 servings

INGREDIENTS

1 (16-ounce) package elbow,
 penne, or gemelli pasta
1½ pounds (4 large or 6
 medium-size) tomatoes
6 tablespoons butter, divided
¼ cup all-purpose flour
2½ cups half-and-half
1 teaspoon salt, divided
½ teaspoon coarsely ground
 black pepper, divided
¼ teaspoon smoked paprika
2 cups (8 ounces) freshly
 shredded cheddar cheese
1 large garlic clove, minced
¾ cup panko breadcrumbs
½ cup (2 ounces) grated
 Parmesan cheese
2 tablespoons chopped
 fresh parsley

Preheat oven to 375°. Lightly grease a 13x9-inch baking dish.

Cook pasta in boiling salted water according to package directions; drain. Pour into prepared dish. Cover and set aside.

Chop half of the tomatoes, removing seeds. Slice the remaining half of the tomatoes. Set aside.

Melt 4 tablespoons butter in a saucepan over medium heat. Add flour; cook, whisking constantly, for 1 to 2 minutes. Whisk in half-and-half, ¾ teaspoon salt, ¼ teaspoon pepper, and paprika. Bring mixture to a boil, reduce heat, and simmer for 2 minutes or until thickened and smooth. Remove from heat; add cheese, stirring until cheese is melted and smooth.

Melt remaining 2 tablespoons butter in a small saucepan over medium heat. Add garlic; cook, stirring constantly, for 3 minutes or until tender. Stir in panko, Parmesan, remaining ¼ teaspoon salt, and remaining ¼ teaspoon pepper. Set aside.

Pour cheese mixture into pasta, stirring until well blended. Stir in chopped tomatoes. Layer sliced tomatoes over top of pasta mixture and sprinkle with panko mixture.

Cover and bake for 20 minutes. Uncover and bake for 10 minutes or until golden brown and bubbly. Sprinkle with parsley.

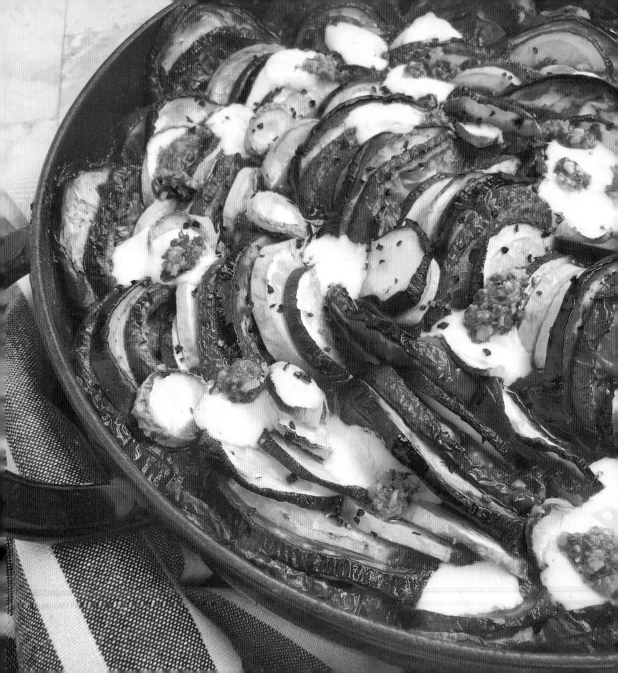

Layered Ratatouille Skillet Casserole

The ingredient list of this pretty vegetable dish might seem long,
but the procedure is simple, especially because it bakes unattended in the oven.
Try to find vegetables with similar diameters so they shingle nicely and cook evenly.

makes 6 servings

INGREDIENTS

- 1 small eggplant, peeled, if desired
- 2 teaspoons salt, divided
- 3 tablespoons olive oil, divided
- 1 medium-size onion, chopped
- 1 red, yellow, or orange bell pepper, chopped
- 1 teaspoon dried Italian seasoning
- Pinch crushed red pepper flakes
- 3 garlic cloves, minced
- 1 teaspoon smoked paprika
- ¼ teaspoon coarsely ground black pepper
- 1 (28-ounce) can seasoned crushed tomatoes, undrained
- 2 tablespoons chopped fresh basil
- 1 teaspoon sugar (optional)
- 1 tablespoon balsamic vinegar
- 1 large zucchini
- 1 large yellow squash
- 1½ pounds (about 6 medium-size) tomatoes
- ¼ cup Pesto Sauce (page 61; optional)
- ½ cup (2 ounces) mozzarella pearls or chopped fresh mozzarella

Cut eggplant into ⅛-inch-thick slices. Sprinkle both sides with 1 teaspoon salt and place on a wire rack set over a rimmed sheet pan. Let stand for 20 to 30 minutes. (Salting the eggplant is optional but can remove excess bitterness.) Pat dry with paper towels.

Preheat oven to 375°.

Heat 1 tablespoon oil in a deep cast iron or other ovensafe skillet over medium-high heat. Add onion, bell pepper, seasoning, and red pepper flakes. Cook, stirring frequently, for 5 minutes or until tender. Add garlic; cook 1 minute. Stir in smoked paprika, remaining 1 teaspoon salt, and pepper. Add canned tomatoes, basil, sugar (omit if using Pesto Sauce), and vinegar, stirring until well blended. Remove from heat.

Cut zucchini, yellow squash, and tomatoes into ⅛- to ¼-inch-thick slices. Arrange sliced vegetables, including reserved eggplant, in layers over sauce in skillet. Brush top of vegetables with remaining 2 tablespoons olive oil.

Cover with aluminum foil and bake for 35 to 40 minutes. Uncover and bake for 15 more minutes or until vegetables are tender. Let rest for 10 minutes. Drizzle with Pesto Sauce, if desired, and sprinkle with cheese.

115

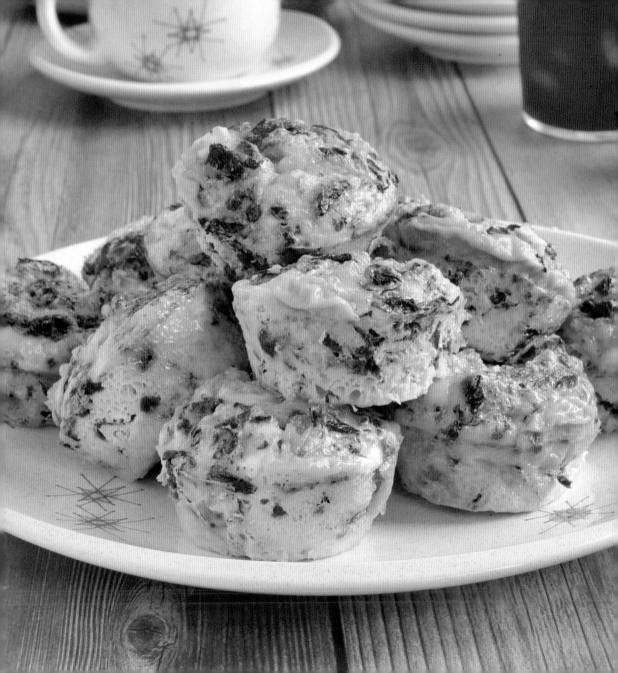

Sun-Dried Tomato, Spinach, and Cheese Cups

I make this on-the-go breakfast treat with pantry staples and items that have a long life in the refrigerator or freezer. You'll have a delicious and healthy offering for company— or any night when you don't want to make a run to the market for other ingredients. I use dry (not packed in oil) sun-dried tomatoes because they are easier to chop. Use oil-packed, if preferred, but make sure they are well drained. If desired, you can add about 3 slices of cooked and chopped bacon or ½ cup cooked ground beef or sausage to ramp up the protein.

makes 1 dozen

INGREDIENTS

- 2 cups frozen cut-leaf spinach, thawed and drained on paper towels
- 12 sun-dried tomatoes, finely chopped
- ½ cup (2 ounces) crumbled feta cheese, shredded cheddar cheese, or other cheese
- 12 large eggs
- ½ teaspoon salt
- ½ teaspoon Greek or Italian seasoning
- 1 teaspoon hot sauce

Preheat oven to 350°. Coat a 12-cup muffin pan with cooking spray or olive oil.

Combine spinach, tomatoes, and cheese in a medium bowl, stirring until well blended. Divide mixture in bottom of prepared muffin cups.

Whisk together eggs, salt, seasoning, and hot sauce in a bowl. Pour evenly over tomato mixture.

Bake for 15 to 20 minutes or until eggs are set. Run a knife around edges of cups to loosen the sides and turn out onto a plate or platter.

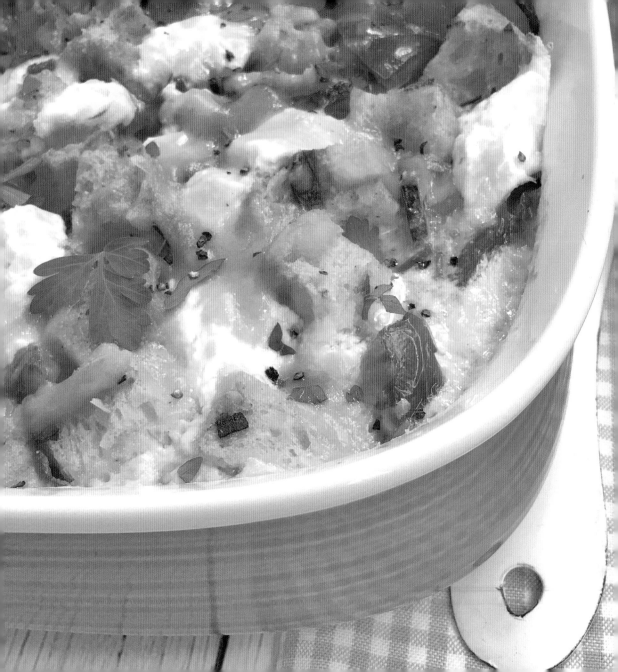

Tomato-Zucchini Strata

Try this vegetarian-friendly breakfast the next time you have company or want a special morning meal.
You can experiment with different types of artisan bread, such as rosemary-sea salt or whole grain oatmeal, etc.
Many of these types of recipes use stale bread, but crisping up the cubes in the oven means you can assemble this right away.

makes 6 servings

INGREDIENTS

8 cups cubed sourdough bread
 (about 1 [14-ounce] loaf)
1 tablespoon butter
½ small red onion, chopped
¼ teaspoon crushed red
 pepper flakes
1 zucchini, halved and sliced
1 large garlic clove, chopped
1 teaspoon salt, divided
1 to 1¼ pounds (about 4
 medium-size) ripe tomatoes,
 cored, seeded, and chopped
2 cups (8 ounces) shredded
 cheddar cheese, divided
8 large eggs
2 cups milk or half-and-half
1 tablespoon chopped fresh chives
 or parsley
½ teaspoon coarsely ground
 black pepper

Preheat oven to 350°. Lightly grease a 9x9-inch baking dish.

Spread bread out on a baking sheet. Bake for 5 minutes or until lightly toasted. (If not baking soon, turn oven off.) Transfer bread to prepared baking dish.

Melt butter in a large skillet over medium heat. Add onion and red pepper flakes. Cook, stirring occasionally, for 5 minutes or until tender. Add zucchini, garlic, and ¼ teaspoon salt. Cook, stirring occasionally, for 5 minutes or until zucchini is tender. Transfer to baking dish and stir in tomatoes and 1 cup cheese.

Whisk together eggs, milk, chives, remaining ¾ teaspoon salt, and black pepper in a medium bowl. Pour egg mixture over bread mixture, pressing down gently. Sprinkle with remaining 1 cup cheese.

Let stand at least 15 minutes or until egg mixture has soaked into the bread cubes. (Or cover and refrigerate overnight. If refrigerated overnight, let casserole stand at room temperature for 15 minutes.)

Preheat oven to 350°. Cover with aluminum foil and bake for 30 minutes. Uncover and bake for 15 to 20 minutes or until golden brown.

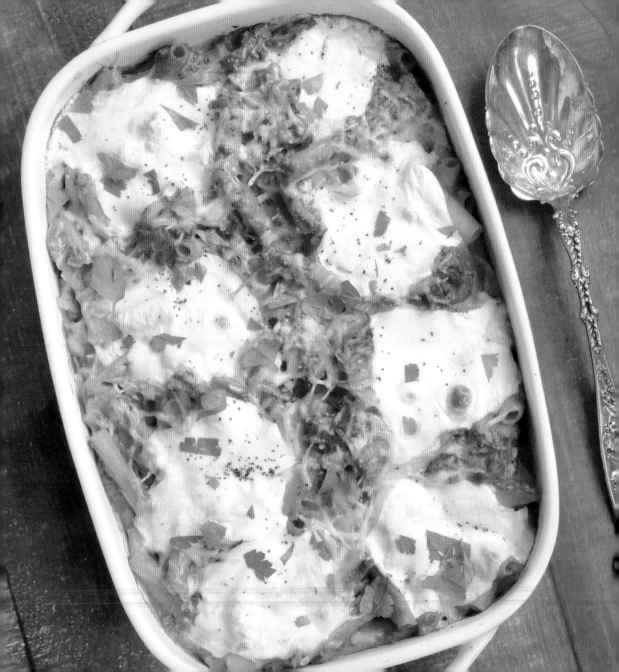

Baked Three-Tomato Ziti

This homey and comforting casserole uses three types of tomatoes—fresh, dried, and sauced.
For ease, the ricotta mixture is stirred into the entire dish. If you want to have a little fun,
spoon in the pasta mixture and alternately dollop the ricotta mixture here and there.

makes 8 to 10 servings

INGREDIENTS

1 (16-ounce) package ziti,
 penne, or other short pasta
1 (15-ounce) container
 ricotta cheese
¾ cup shredded Parmesan
 cheese, divided
½ cup jarred sun-dried tomatoes
¼ chopped fresh basil
1 tablespoon chopped
 fresh rosemary
1 teaspoon salt
½ teaspoon coarsely ground
 black pepper
1 tablespoon extra-virgin olive oil
1 medium-size onion, chopped
¼ to ½ teaspoon crushed red
 pepper flakes
3 garlic cloves, minced
12 ounces ground turkey, beef,
 or vegetable meat crumbles
2 cups Insta-fresh Tomato Sauce
 (page 39) or store-bought
 tomato or pasta sauce
8 ounces fresh mozzarella, sliced
2 heirloom tomatoes, thinly sliced
1 tablespoon chopped fresh
 Italian parsley

Preheat oven to 375°. Lightly grease a 13x9-inch baking dish.

Cook pasta in boiling salted water according to package
directions. Drain and return to pot.

Combine ricotta, ½ cup Parmesan, sun-dried tomatoes, basil,
rosemary, salt, and pepper in a bowl.

Heat oil in a large skillet over medium heat. Add onion
and red pepper flakes. Cook, stirring frequently, for 5 to
8 minutes or until onion is tender. Stir in garlic and turkey.
Cook, stirring frequently, until meat is browned and crumbly.
Drain, if necessary, and return to pan. Add tomato sauce,
stirring until well blended. Stir turkey mixture into pasta.
Stir ricotta mixture into pasta.

Spoon pasta mixture into prepared dish. Arrange sliced
mozzarella and tomatoes evenly over top. Sprinkle with
remaining ¼ cup Parmesan cheese. Bake for 30 minutes
or until hot and bubbly.

Let cool for 10 minutes before serving. Sprinkle with parsley.

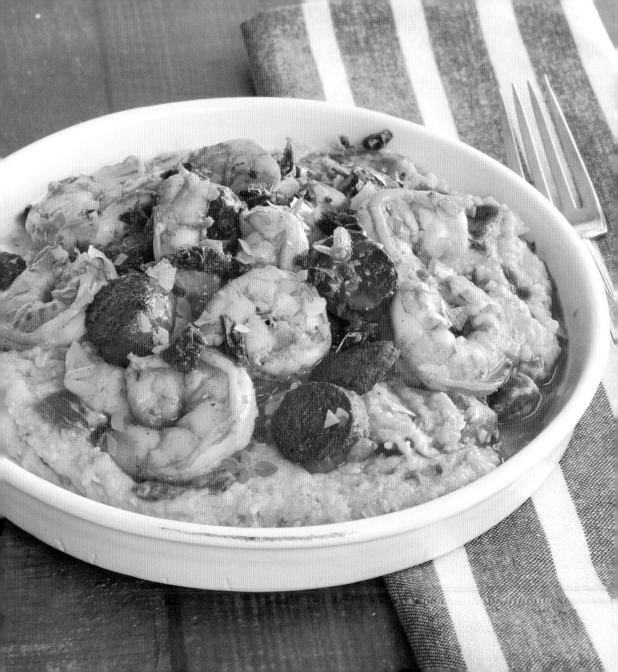

Shrimp with Cheesy Tomato Grits

The decadent grits recipe can be served without the shrimp, as a side,
but they are best with the seafood topping in this interesting version of the classic Lowcountry dish.

makes 4 servings

INGREDIENTS

Cheesy Tomato Grits
 (recipe at right)
1 (12-ounce) package smoked or
 andouille sausage, sliced
2 tablespoons butter
2 shallots, minced
2 pounds medium-size shrimp,
 peeled and deveined
¼ cup sun-dried tomatoes, dried
 or oil-packed
1 teaspoon fresh thyme leaves
1 tablespoon fresh lemon juice
¼ cup white wine
2 teaspoons
 Worcestershire sauce
Chopped parsley and/or
 green onions

Prepare grits; cover and keep warm.

Brown sausage in a skillet over medium-high heat; remove from pan. Melt butter in skillet. Add shallots; cook, stirring constantly, for 2 minutes.

Add shrimp, and cook for 2 to 3 minutes. Stir in tomatoes, thyme, lemon juice, wine, and Worcestershire sauce. Cook for 3 minutes or until thoroughly heated. Stir in sausage.

Spoon grits into individual shallow bowls; top with shrimp mixture. Sprinkle with parsley.

Cheesy Tomato Grits: Melt **2 tablespoons butter** in a saucepan over medium-high heat. Add **3 large tomatoes, seeded and coarsely chopped,** and **2 minced garlic cloves.** Cook, stirring frequently, until tender. Stir in **2 cups chicken broth, 1 cup heavy whipping cream or milk,** and **1 (4.5-ounce) can chopped green chilies,** undrained. Bring to a boil and whisk in **1 cup quick-cooking grits.** Reduce heat to low; cook, stirring occasionally, for 5 minutes or until grits are tender. Remove from heat; stir in **2 tablespoons butter, 1 cup (4 ounces) Parmesan cheese, ½ teaspoon salt,** and **½ teaspoon freshly ground black pepper.** Makes 4 servings.

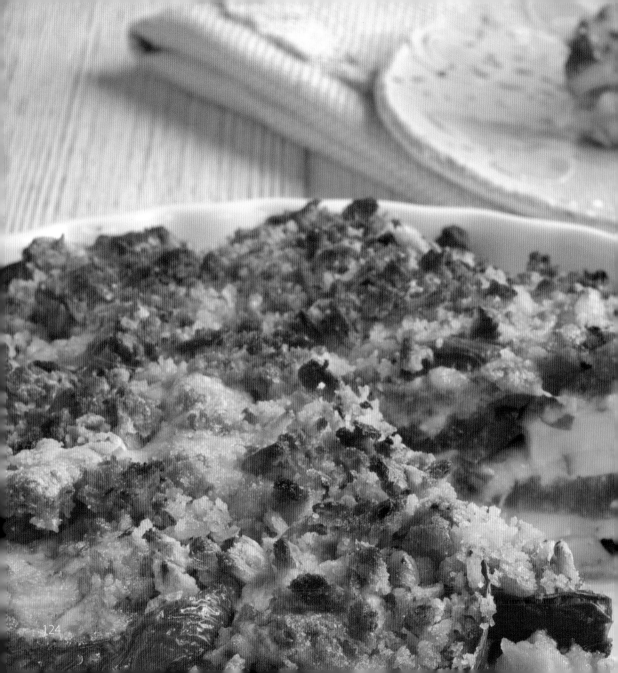

pies and tarts

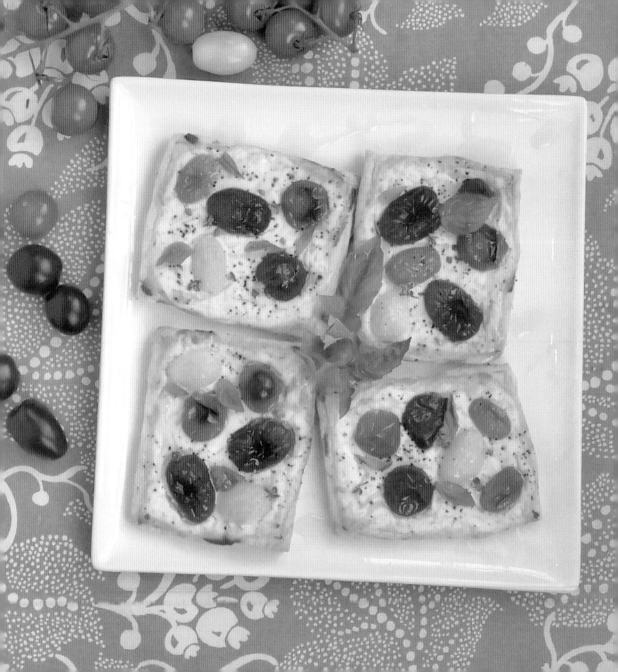

Tomato–Ricotta Tart

Wow guests with a pretty appetizer while you've got the rest of the food cooking.
For a complete meal, serve with a hearty tossed salad on the side. Many recipes
using phyllo dough require melted clarified butter to be brushed between the sheets.
Instead, I misted the surface with olive oil cooking spray as a shortcut, with good results.

makes 8 servings

INGREDIENTS

2 pounds mixed tomatoes,
 cored, seeded, and sliced
2 tablespoons extra-virgin
 olive oil
1 small garlic clove, minced
1 cup (4 ounces) shredded
 or grated Parmesan cheese
 divided
¼ cup plain or
 seasoned breadcrumbs
1 (16-ounce) package phyllo
 dough, thawed
Olive oil cooking spray
1 (15-ounce) container
 ricotta cheese
1 teaspoon lemon zest
½ teaspoon salt
2 egg whites
⅓ cup slivered or chopped
 fresh basil
¼ teaspoon coarsely ground
 black pepper

Preheat oven to 400°. Line a baking sheet with nonstick
aluminum foil or parchment paper.

Combine tomatoes, olive oil, and garlic in a small bowl.
Let marinate for 15 minutes.

Combine ½ cup Parmesan cheese and breadcrumbs in a
small bowl. Place 1 sheet phyllo on prepared baking sheet.
Spray lightly with cooking spray. Sprinkle with 1 tablespoon
breadcrumb mixture. Repeat with remaining phyllo and
breadcrumb mixture.

Combine ricotta, remaining ½ cup Parmesan, zest, salt, and
egg whites in a bowl. Spread ricotta mixture on top of phyllo,
leaving a ½-inch border. Arrange tomatoes over ricotta.

Bake for 30 minutes or until golden brown and puffed around
the edges. Sprinkle with basil and pepper.

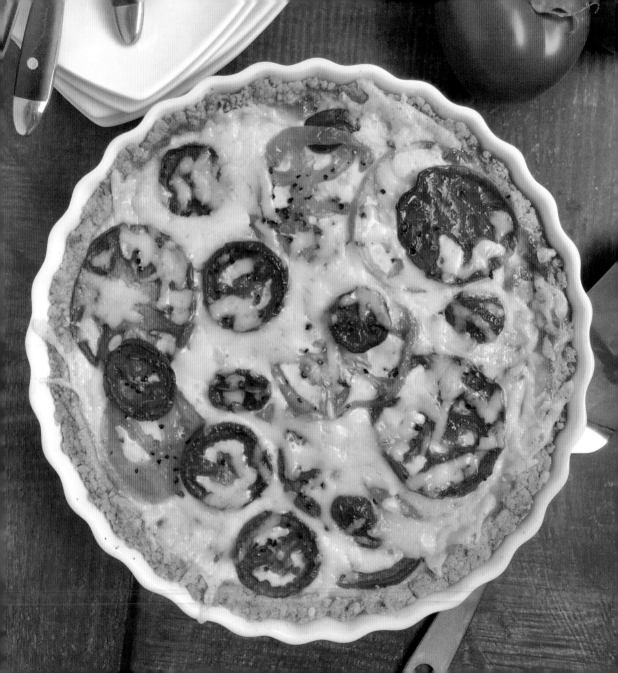

Tomato and Three-Cheese Quiche

A blend of yellow, brown, plum, and cherry tomatoes makes this tart as pretty as it is delicious.
Swap out the goat cheese for feta, brie, or shredded smoked Gouda for a change.

makes 8 servings

INGREDIENTS

Cheddar Crust (recipe at right)
2 ounces soft goat
 cheese, crumbled
3 large eggs
¾ cup half-and-half or milk
½ teaspoon hot sauce
¼ teaspoon salt
1 pound mixed ripe tomatoes,
 thinly sliced
½ cup (2 ounces) shredded
 mozzarella cheese
¼ teaspoon cracked black pepper

Preheat oven to 375°.

Prepare Cheddar Crust and sprinkle dollops of goat cheese in the bottom.

Whisk together eggs, half-and-half, hot sauce, and salt in a bowl. Pour into crust.

Arrange tomatoes over egg mixture and sprinkle with mozzarella cheese and black pepper. Bake for 30 minutes.

Cheddar Crust: Combine **1 cup (4 ounces) shredded cheddar cheese, ¾ cup all-purpose or gluten-free flour,** and **½ teaspoon salt** in a large bowl. Add **4 tablespoons unsalted** or **salted butter, cut into pieces,** cutting in with a pastry blender or fork until a shaggy dough forms. Press mixture into a 9–9½-inch quiche or shallow tart pan. Makes 1 crust.

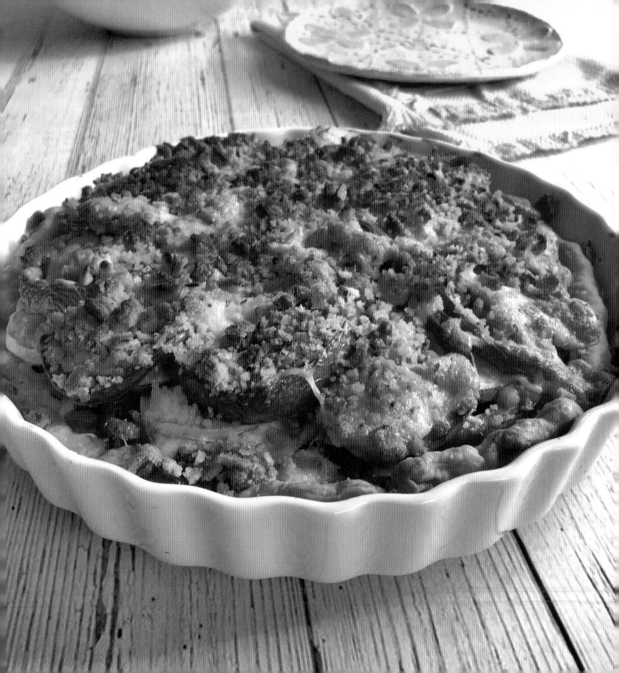

Cheesy Tomato–Squash Tart

Tomatoes often conspire with zucchini and yellow squash to take over your garden.
Try this delightful recipe for any meal—breakfast, lunch, or a light dinner served with a salad.
Brushing the egg on the crust, removing the tomato seeds and gel, and salting and precooking
the squash helps to seal the crust and keep the veggies from watering out during baking.

makes 8 servings

INGREDIENTS

1 purchased refrigerated piecrust
1 egg, lightly beaten
1 large or two small zucchini or yellow squash, sliced
1 teaspoon salt, divided
½ cup (2 ounces) smoked cheddar, Provolone, or mozzarella cheese
½ cup (2 ounces) shredded or grated Parmesan cheese
¼ cup mayonnaise
1 tablespoon chopped fresh basil
1 teaspoon chopped fresh thyme or oregano
1½ pounds (about 4 medium-size to large) ripe tomatoes, seeded and sliced
½ cup crushed saltines, cheddar cheese crackers, or buttery round crackers
1 tablespoon melted butter or olive oil

Preheat oven to 425°.

Place piecrust in a 9-inch shallow tart pan. Prick bottom and sides with a fork. Brush bottom lightly with egg (you won't need to use it all). Bake for 10 minutes or until just starting to color.

Sprinkle zucchini evenly on both sides with ½ teaspoon salt and place on a microwave-safe plate. Microwave on high for 2 to 3 minutes or until tender. Wipe liquid from zucchini with paper towels. Set aside.

Combine cheddar, Parmesan, mayonnaise, basil, thyme, and remaining ½ teaspoon salt in a large bowl.

Layer half of the zucchini, half of the tomatoes, and half of the cheese mixture into the crust. Repeat with remaining half of the zucchini, tomatoes, and cheese mixture.

Combine cracker crumbs and butter; sprinkle over the top.

Bake for 20 minutes or until golden brown.

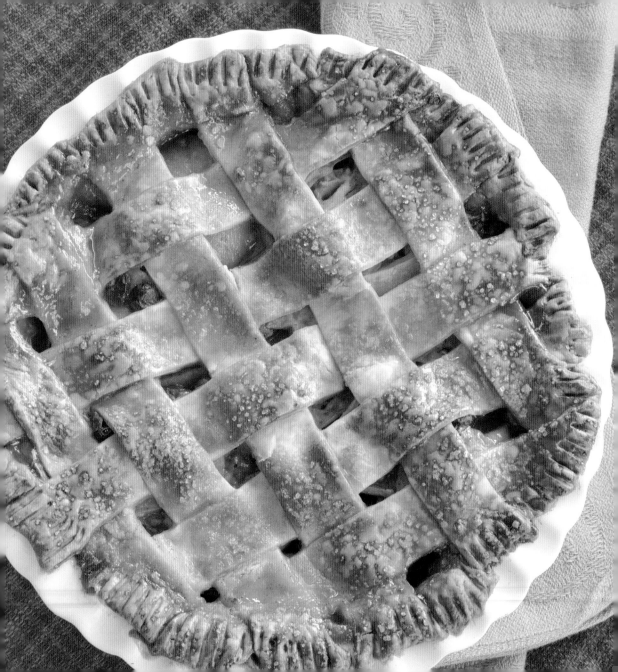

Green Tomato Pie

If you don't mention it, no one will guess that this sweet and spiced dessert was not made from apples! It makes a great transition dessert from summer to fall when you've still got green tomatoes but frosts have taken down the vines.

makes 8 servings

INGREDIENTS

½ cup granulated sugar
½ cup firmly packed light brown sugar
⅓ cup all-purpose flour
¾ teaspoon ground cinnamon
¼ teaspoon ground cloves
¼ teaspoon salt
½ teaspoon lemon zest
2 pounds (6 medium-size) green tomatoes, cored and thinly sliced
⅓ cup golden raisins
1 (14.1-ounce) package refrigerated piecrusts or 2 homemade pastry crusts
4 tablespoons salted or unsalted butter, cut into small pieces
1 egg
1 teaspoon turbinado or granulated sugar

Preheat oven to 350°.

Combine sugar, brown sugar, flour, cinnamon, cloves, salt, and zest in a large bowl. Add tomatoes and raisins, tossing to coat.

Fit one crust in bottom of a 9-inch pie plate. Cut remaining pastry into 1-inch strips.

Arrange tomato mixture in piecrust, making sure the sugar mixture is evenly distributed. Top evenly with butter.

Arrange pastry strips in a lattice pattern on top of tomatoes. Crimp and seal edges.

Brush lattice with egg and sprinkle with sugar.

Bake for 60 minutes or until tomatoes are tender and pastry is golden brown. For cleaner slices, cool before serving.

Index

EXPLORE THE ENTIRE SERIES OF
Nature's Favorite Foods Cookbooks!

978-1-59193-907-8
$16.95

978-1-59193-847-7
$16.95

978-1-59193-931-3
$16.95

978-1-59193-828-6

978-1-59193-909-2

978-1-59193-950-4

About the Author

Julia Rutland is a Washington, D.C.-area writer, recipe developer, and master gardener whose work appears regularly in publications and websites such as *Southern Living* magazine, *Coastal Living* magazine, and Weight Watchers books. She is the author of *Discover Dinnertime, The Campfire Foodie Cookbook, On a Stick, Blueberries, Squash, Apples, Foil Pack Dinners,* and *101 Lasagnas & Other Layered Casseroles.* Julia lives in the D.C. wine country town of Hillsboro, Virginia, with her husband, two daughters, and many furred and feathered friends.